A MODERN PATRONAGE

de Menil Gifts to American and European Museums

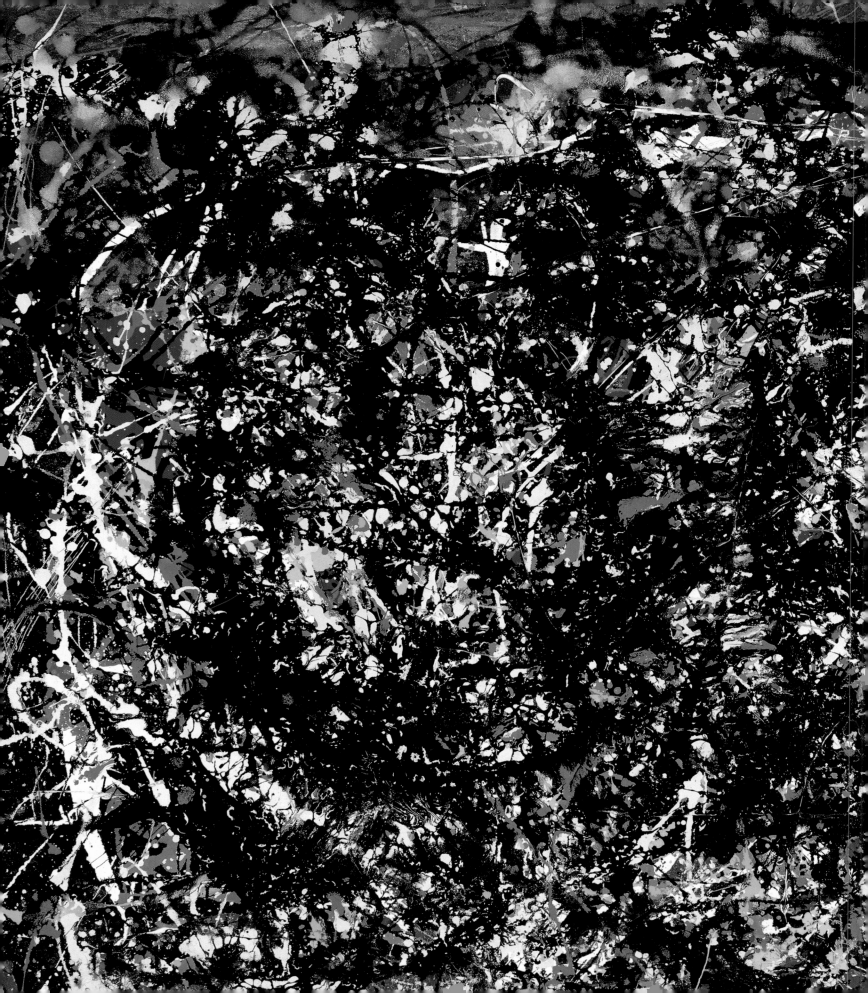

A MODERN PATRONAGE

de Menil Gifts to American and European Museums

MARCIA BRENNAN

ALFRED PACQUEMENT

ANN TEMKIN

WITH AN INTRODUCTION BY

JOSEF HELFENSTEIN

THE MENIL COLLECTION

Yale University Press, New Haven and London

Published on the occasion of the exhibition
"A Modern Patronage: de Menil Gifts
to American and European Museums"
Organized by The Menil Collection
Curated by Josef Helfenstein, Director

The Menil Collection, Houston
June 8–September 16, 2007

This exhibition is generously supported by The Brown
Foundation; Hermès; The Elkins Foundation; Fayez Sarofim;
Schlumberger with support of the Texan-French Alliance for
the Arts; Mr. and Mrs. Peter Hoyt Brown; Dr. and Mrs. Edmund
Carpenter; Christophe de Menil; The Eleanor and Frank Freed
Foundation; The Hobby Family Foundation; Nina and Michael
Zilkha; SYSCO Corporation; Allison Sarofim; Sotheby's;
Embassy and Consulate General of France Cultural Services;
The Cullen Foundation; and the City of Houston.

PROJECT DIRECTOR: Laureen Schipsi
RESEARCH AND EDITORIAL ASSISTANT: Michelle White
TEXT EDITOR: Susan F. Rossen
GRAPHIC DESIGNERS: Miko McGinty and Rita Jules

TYPEFACE: Akzidenz Grotesk
PAPER: GardaMatt
COLOR SEPARATIONS, PRINTING, AND BINDING:
Stamperia Valdonega Group, Verona, Italy

Published by
Menil Foundation, Inc.
1511 Branard Street
Houston, Texas 77006

Distributed by Yale University Press
P.O. Box 209040
302 Temple Street
New Haven, Connecticut 06520-9040
www.yalebooks.com

FRONT COVER: René Magritte (1898–1967). *L'empire des
lumières II* (*The Empire of Light II*), 1950. See plate 22, p. 76.
BACK COVER: *Standard Bearer*, Aztec, 1425–1521. See
plate 20, p. 59.
FRONTISPIECE: Jackson Pollock (1912–1956). *Number 6*,
1949 (detail). See plate 12, p. 51.

ISBN 978-0-300-12379-1 (hardcover: Yale University Press)
Library of Congress Control Number: 2006936664

Unless otherwise noted, all archival photographs are courtesy
Menil Archives or Object Files, The Menil Collection, Houston.

CONTENTS

Acknowledgments

TO CELEBRATE The Menil Collection's twentieth anniversary, we decided to organize an exhibition that would capture the collaborative nature of John and Dominique de Menil's patronage by bringing together works of art they gave to major museums in the United States and France. We intend "A Modern Patronage" to be a testament to their generosity, deep curiosity, and belief in the spiritual value of the art object, as well as their energetic involvement with artists, scholars, and museum professionals. We trust that the work we have brought together here serves as both a homecoming and an illustration of the rich and dynamic activities that led to the creation of The Menil Collection in Houston in 1987.

This exhibition could not have happened without the support of the lending institutions, places in which the de Menils believed. My sincere thanks go to my colleagues Glenn D. Lowry, Director, The Museum of Modern Art, New York; Stéphane Martin, President, Le Musée du Quai Branly, Paris; Peter C. Marzio, Director, Museum of Fine Arts, Houston; and Alfred Pacquement, Director, Musée National d'Art Moderne/Centre de Création Industrielle/Centre Georges Pompidou, Paris.

The Menil's Board of Trustees has enthusiastically supported this project; my special thanks go to Louisa Stude Sarofim, President. The board's energy has been matched by the dedication of our staff. I am grateful to Curatorial Assistant Michelle White, who adeptly coordinated the exhibition and devoted much time and effort to the creation of this catalogue. She was supported by Curator of Modern and Contemporary Art Franklin Sirmans and Associate Curator Kristina Van Dyke, who expertly provided input in the selection of non-Western works, and participated in discussions that led us in productive, new directions. Assistant Curator Clare Elliott and Curatorial Assistant Miranda Lash, with the support of Chief Librarian Phil Heagy and Assistant Librarian Stephanie Capps, contributed valuable research to the project, as did our dedicated Intern Mary Lambrakos. Collections Registrar Mary Kadish and Archivist Geri Aramanda were invaluable resources. Their unfailing ability to recall the people and places and art that have played an important role in the museum, as well as their ability to always produce supporting archival materials, has been the guiding historical voice of this exhibition from its inception. Matthew Drutt, former Chief Curator, deserves recognition for his work during the beginning, and critical, stages of the project.

Head of Art Services Thomas Walsh, Preparators Tobin Becker and Peter Bernal, and Framer Debby Breckeen, along with Exhibitions Designer Brooke Stroud and Exhibition Design Assistant Kent Dorn warrant special thanks for their thoughtful installation. Chief Registrar Anne Adams and Assistant Registrar Judy Kwon gracefully choreographed the safe transport of art to and from Houston. Once here, Facilities and Security Manager Steve McConathy and his staff ensured the works' safety while on the premises. Chief Conservator Brad Epley and his staff must also be recognized for their guidance in the

selection of objects, as well as their reliable solutions to the demanding problems and logistics required by an exhibition of this scale.

I express heartfelt appreciation for the dedication to this project of the Development Department. This exhibition is one of many projects for the anniversary year, and the efforts of Director of Planning and Advancement Will Taylor and his staff: Director of Development Tripp Carter, Special Events Coordinator Elsian Cozens, Membership Coordinator Marta Galicki, Communications Director Vance Muse, and Director of Principal Gifts Mary Ann Pack, have been tireless. Thanks to Manager of Finance Tom Madonna and Chief Financial Officer E. C. Moore for their administrative management. Director of Public Programs Karl Kilian and Program Coordinator Anthony Martinez conceived of an impressive group of lectures and events that have greatly enhanced this celebration. As always, I am grateful for the ability and foresight of my assistant, Kristin Schwartz-Lauster.

We are especially fortunate for the expertise of Manager of Publications Laureen Schipsi, who oversaw the development of this catalogue and the myriad responsibilities related to its publication. We are grateful for the contributions of essayists Marcia Brennan, Alfred Pacquement, and Ann Temkin. We have again benefited from the keen eye and thoughtful approach of catalogue designers Miko McGinty and Rita Jules. Susan F. Rossen carefully edited the catalogue texts. At Yale University Press, we would like to acknowledge the support and assistance of Patricia Fidler and Carmel M. Lyons. Special thanks also go to Joanna Cook and Carol Price for their patience in coordinating the images rights for the publication, and to Publications Assistant Erh-Chun Amy Chien for her assistance with the catalogue.

For their help with our research-related inquiries, we would like to thank Nécha Mamod, Musée National d'Art Moderne; Conservator Dominique Jacquot, Musée des Beaux-Arts, Strasbourg; Collections Registrar Laurence Dubaut and Curator for African Collections Hélène Joubert, Musée du Quai Branly; Brigitte Vincens at the Centre Pompidou; and David Aylsworth, Alison de Lima Greene, Frances Marzio, Margaret McKee, Wynne Phelan, Tony Rubio, Amy Scott, and Mary Stein at the Museum of Fine Arts, Houston.

Finally, my profound gratitude goes to the sponsors of this exhibition: The Brown Foundation; Hermès; The Elkins Foundation; Fayez Sarofim; Schlumberger with support of the Texan-French Alliance for the Arts; Mr. and Mrs. Peter Hoyt Brown; Dr. and Mrs. Edmund Carpenter; Christophe de Menil; The Eleanor and Frank Freed Foundation; The Hobby Family Foundation; Nina and Michael Zilkha; SYSCO Corporation; Allison Sarofim; Sotheby's; Embassy and Consulate General of France Cultural Services; The Cullen Foundation; and the City of Houston.

JOSEF HELFENSTEIN
DIRECTOR

December 9, 1955

Mr. Alfred H. Barr, Jr.
New York

Dear Alfred:

I am very glad to confirm our decision to give to
the Museum of Modern Art the Max Ernst bronze "The
King Playing with the Queen." It will be a gift of
Mr. and Mrs. John de Menil, Houston, Texas.

This sculpture is reproduced on page 79 of "Max Ernst:
Beyond Painting," Wittenborn, New York, 1948. It is
listed there under the name "The King Playing with
the Queen." The plaster was made in 1944 while Max
was staying with Robert Motherwell in Long Island.
Six bronze casts were made in 1954.

I am very glad indeed that your Accessions Committee
liked "The King," and I thank you for the kind words
which you are sending us on their behalf and in your
own name. We feel very close to the Museum of Modern
Art, and we like to give you the kind of things in
which we believe. We believe in Max Ernst. We have
several of his paintings. We have two casts of "The
King," one in New York, as you know, and one in
Houston, and we think it is a wonderful piece to
live with.

I am very glad that the Committee liked the stone
"Head" by Polygnotos Vagis. I will write you further
about this in the early part of next year.

With kind regards.

 Yours sincerely,

 John de Menil

JdM/as

INTRODUCTION

JOSEF HELFENSTEIN

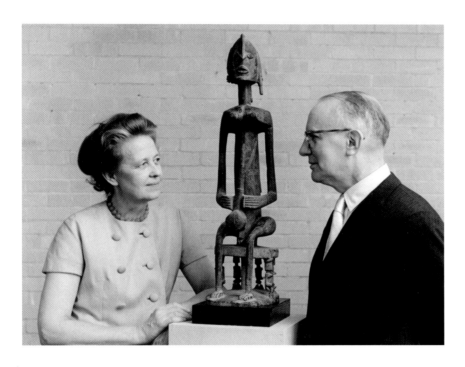

FIGURE 2. Dominique and John de Menil, 1967, pictured with *Seated Figure*, Mali, Dogon.

OPPOSITE: FIGURE 1.
Letter from John de Menil to Alfred H. Barr Jr., December 9, 1955.

IN DECEMBER 1955, John de Menil wrote to Alfred H. Barr Jr., the founding director of The Museum of Modern Art, New York (MOMA), on the occasion of one of his and Dominique de Menil's first major gifts to a museum (figure 1). Setting forth the couple's intention to donate Max Ernst's *The King Playing with the Queen*, 1944 (plate 2, p. 13), a Surrealist bronze sculpture of a horned creature engaged in a magical game of chess, John's straightforward language reflects the de Menils' passionate belief not only in the artwork, but also in the artist and the museum: "We feel very close to the Museum of Modern Art," he wrote, "and we like to give you the kind of things in which we believe. We believe in Max Ernst."[1] The activities that defined the de Menils as art patrons were guided by a profound, indefinable respect for artists and their work, upheld by a faith in art's social and redemptive qualities. Through the act of patronage, the de Menils shared this deeply held, spiritually based philosophy with many American and European museums.

John (1904–1973) and Dominique (1908–1997) de Menil (figure 2) never regarded their giving as an isolated gesture but rather as a component of a dynamic intellectual exchange among a community of artists, scholars, museum professionals, and students. They often went to extraordinary lengths

to ensure that the things in which they believed were experienced and valued by others. This unusual and holistic approach to patronage necessitated a close involvement with the artist, a scholarly interest in the object, and a sensitivity in determining not only what work to give but to whom it should be given. The degree to which the de Menils supported artists is clearly evident in the commitment they made to a number of them. For example, the couple first met Ernst in Paris in 1934, when he was still a relatively unknown German artist, and commissioned him to paint a portrait of Dominique (figure 22, p. 69). Years later, after the de Menils and Ernst had settled in the United States, the couple started to collect the artist's work, giving important pieces to the Museum of Fine Arts, Houston (MFAH), and a bronze sculpture, *Anxious Friend*, 1944 (figure 3), to the Solomon R. Guggenheim Museum, New York. In 1952, the same year that they invited Ernst to Houston for his first one-person museum exhibition in the United States, the de Menils saw the original plaster of *The King Playing with the Queen* in Robert Motherwell's studio on Long Island. Convinced that the work should be cast in bronze, they commissioned castings (figure 4), donating one to MOMA and later another to Motherwell.[2] Another example of this level of support occurred in 1965, when John de Menil purchased an entire exhibition of the mechanical sculptures of the Swiss artist Jean Tinguely (see plates 5, 7, 9; pp. 43, 45, 47). In what has become an almost mythic story, John de Menil saw the ensemble at Alexander Iolas's Paris gallery in December 1964. He was so impressed by the cacophonous gathering of spurting and rocking kinetic machines that he acquired everything in the show for the MFAH. While a seemingly impulsive purchase, in actuality it stands as yet another testament to the couple's depth of commitment to artists and their works.

While the de Menils could spontaneously respond to works of art, their decisions to buy a piece or donate one to a museum were often guided by careful research. The Menil Collection's object files are filled with correspondence the couple maintained with scholars, artists, museum directors, curators, and dealers in their attempts to determine a piece's correct classification, authenticity, and provenance. This close attention to detail and the de Menils' continuing dedication to works of art after they had donated them is evident in a body of letters relating to the de Menils' gift to MOMA of *Painting*, 1946–47, by Wols (plate 29, p. 84). John de Menil, MOMA's curatorial staff, and a Wols scholar corresponded for years about the proper orientation of the canvas, with John tracing its provenance and documenting the condition of the support and the markings on the stretcher bars.

The de Menils developed strong ties with many institutions, including the Musée National d'Art Moderne (MNAM), the umbrella institution

FIGURE 3. Max Ernst (1891–1976). *Anxious Friend*, 1944, cast 1957. Bronze. 26½ x 13⅞ x 16 in. (67.3 x 35.2 x 40.6 cm). Solomon R. Guggenheim Museum, Gift, Dominique and Jean de Menil, 1959 (59.1521).

that would form the Centre Georges Pompidou, Paris, in 1977. In 1975, two years after her husband's death, Dominique de Menil paid tribute to him with a gift to the museum. Pontus Hulten had just been named the MNAM's director, and Dominique knew that John would have wanted to make a "grand gesture," so she facilitated the purchase of Jackson Pollock's monumental painting *The Deep*, 1953 (plate 35, p. 105), for the museum's nascent collection of modern American art.[3] Deliberately seeking something that would appropriately honor her husband's memory and his dedication to art, she saw in Pollock's canvas extraordinary emotional power and an opportunity to ignite an appreciation of American Abstract Expressionism in France at a time when the nation's collections contained few examples of this important movement. In a letter to Hulten, Dominique de Menil explained that she was committed to the burgeoning modern-art institutions in France and that she hoped such a magnificent work would inspire others to give, ending with the infectious words, "Dynamism is contagious."[4]

In an even more direct way, patronage served as a means to extend John and Dominique de Menil's political beliefs. In 1969 they received a gift of two *Electric Chair* paintings, 1967, from Andy Warhol (plates 42, 44; pp. 113, 115). In a letter of thanks to the artist, John articulated the power of giving as a tool of social leverage. Referring to the French priest who had introduced him and his wife

to modern art in New York during World War II, he said, "Our late friend Father [Marie-Alain] Couturier told us once that the work of the artists is their great gift to the world, and here we are acknowledging the gift to our foundation of two of your works which indeed are important to the world."[5] Later, when Dominique de Menil was selecting additional pieces to donate to the Centre Pompidou, among her choices was one of her *Electric Chair* paintings (plate 42, p. 113). While she owned other Warhols, she selected a macabre meditation on capital punishment, a stark contrast to the artist's more well-known appropriations of mass culture. She also gave Larry Rivers's *I Like Olympia in Blackface*, 1970 (plate 40, p. 111), a satirical reversal of Édouard Manet's famous and scandalous *Olympia*, 1863 (Musée d'Orsay, Paris), depicting a reclining white prostitute. The de Menils had commissioned the work for a 1971 exhibition addressing racial politics in the United States.[6] Subtly subversive, these two unlikely representations of American Pop Art given to a French museum speak to the couple's use of patronage to expand the stage for their humanitarian goals and investment in social justice.

In addition to donations of modern and contemporary work, the de Menils facilitated the acquisition of non-Western art by museum collections with the same thoughtful consideration. In 1965 John de Menil, working with the French dealer Charles Ratton, selected an Asante *Kuduo*

FIGURE 4. Max Ernst's *The King Playing with the Queen*, en route to the foundry for casting. Long Island, New York, 1953.

PLATE 1. Max Ernst (1891–1976). *Asperges de la lune (Lunar Asparagus)*, 1935, cast 1972. Bronze, edition 6/6. 64½ x 13 x 8½ in. (163.8 x 33 x 21.6 cm).

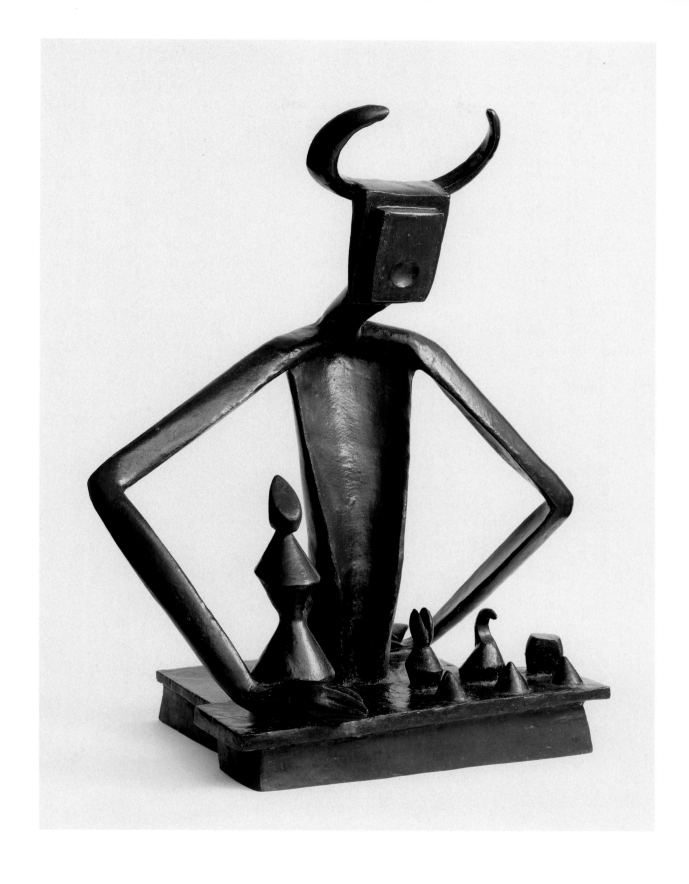

PLATE 2. Max Ernst (1891–1976). *The King Playing with the Queen*, 1944, cast 1954. Bronze, edition 2/9. 37¾ x 33 x 21¼ in. (95.9 x 83.8 x 54 cm).

(plate 3, p. 15), a bronze offering vessel, for the Musée de l'Homme, Paris (now the Musée du Quai Branly). Revealing his affection for the institution, he wrote, "When we are in Paris, we like to go to the Musée de l'Homme and to drift along quietly, visiting old friends in the glass cases and discovering new ones."[7] The *Kuduo* itself is an apt metaphor for The Menil Collection, and it seems fitting in the context of this exhibition that its purpose is to contain precious objects that symbolically represent the soul. Like works of art, which theoretically exist beyond their container, this vessel is a poetic referent to the intangible ideas that it holds.

"A Modern Patronage: de Menil Gifts to American and European Museums" is presented in honor of the museum's twentieth anniversary. We thought it appropriate to bring "home" some of the works that the de Menils held dear and gave to this and other institutions for which they cared deeply.[8] For the first time, most of the major works of art donated to museums in Europe and the United States — including the Musée National d'Art Moderne, Centre Georges Pompidou, Paris; The Museum of Modern Art, New York; Museum of Fine Arts, Houston; Musée du Quai Branly, Paris; and The Menil Collection — have been brought together. The exhibition comprises examples by Ernst, René Magritte, Man Ray, Mark Rothko, Tinguely, and Wols, as well as Lee Bontecou, Christo, Claes Oldenburg, Pollock, Rivers, and Warhol, and important selections of African, Oceanic, and Pre-Columbian art.

The essays in this catalogue situate the de Menils' patronage in its historical context. Marcia Brennan, associate professor of art history at Rice University, Houston; Ann Temkin, curator in the Department of Paintings and Sculpture at The Museum of Modern Art; and Alfred Paquement, director of the Musée National d'Art Moderne, Centre Georges Pompidou, have written essays that, while varied in scope, trace the personal and professional relationships the de Menils developed with the legendary museum directors James Johnson Sweeney, Alfred H. Barr Jr., and Pontus Hulten, respectively. Together, these texts constitute an invaluable contribution to our institutional history. They illustrate how the de Menils' philanthropy influenced major collections of modern art in Houston, New York, and Paris, and demonstrate the wide reach of their activities as patrons.

Bertrand Davezac, a former Menil curator, used French author and art theorist André Malraux's phrase "le musée imaginaire" — the museum without walls — to describe the formation of The Menil Collection. He likened the museum's non-chronological, non-hierarchical, and non-encyclopedic collection to Malraux's borderless and pan-cultural conceptualization of an ideal museum.[9] This comparison seems all the more fitting for the present celebration of the museum as it enters its third decade, for "the museum without walls" can be extended as a metaphorical model for the de Menils' unique and visionary concept of patronage, which was always guided by the recognition that the work of art can only exist in relation to the people,

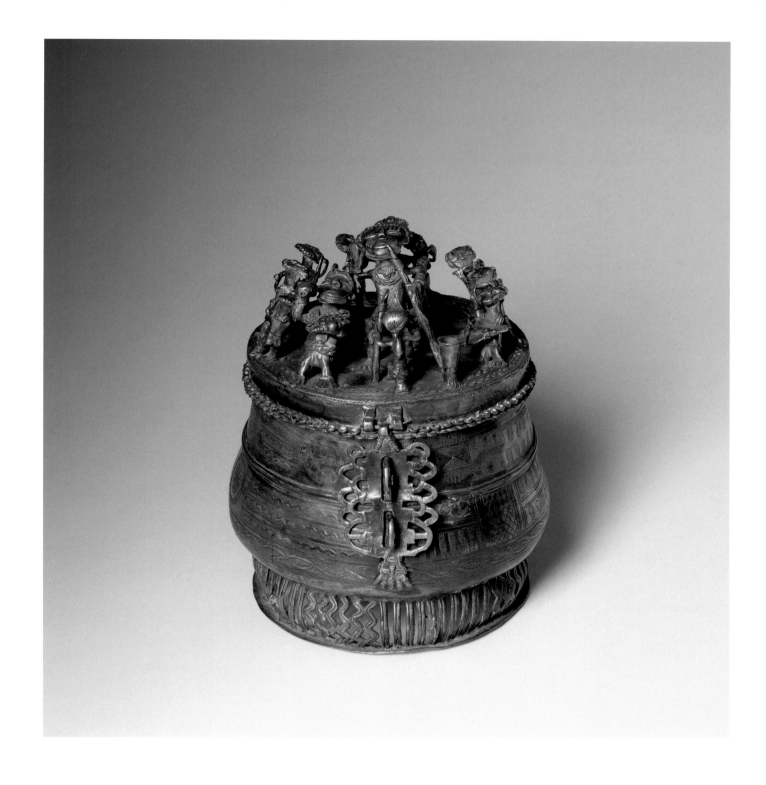

PLATE 3. *Vessel* (*Kuduo*). Ghana; Asante, n.d.
Copper alloy cast by lost-wax process. 10⅝ x 9½ x 9¼ in. (26.9 x 24 x 23.5 cm).
MUSÉE DU QUAI BRANLY, PARIS; DE MENIL GIFT, 1965 (FROM THE MUSÉE DE L'HOMME, PARIS) 15

places, and ideas that shape it. Not unlike the famous photograph of Malraux contemplating a sea of reproductions of masterpieces, archival photographs of Dominique de Menil in 1973 engrossed in planning an Ernst exhibition (figures 5, 6) suggest that the ideal museum is actually a way of thinking.

In planning "A Modern Patronage," originally conceived as something of a simple reunion and homage, a fascinating story has unexpectedly emerged. Bringing together the pieces of the puzzle, so to speak, has provided an opportunity to understand the philosophy that guided the de Menils' decisions and unique approach to patronage. The Menil Collection, a destination for international and national visitors as well as Houstonians, is as much the spirit that permeates the campus — even before one enters Renzo Piano's critically acclaimed

building — as it is a receptacle for works of art (figure 7). I hope this exhibition helps to illustrate that our institution is not a static symbol, but is still very much an intellectual undertaking and embodiment of the founders' open-door approach to thinking about the possibilities of art. When I first visited the Menil, I was immediately struck by the ability of a painting by Barnett Newman to exist in harmony with an African sculpture, due to a thoughtful approach to display. Like the dialogue such an aesthetic juxtaposition creates, the de Menils' philanthropy paved the way for new connections. As Dominique de Menil once said, "I am one of many who believe that we cannot live in isolation because isolation leads to sterility and eventually destructive confrontation. I am one of many who believe that, not only can we maintain our identity but we can enrich it by contact and exchanges with others."[10]

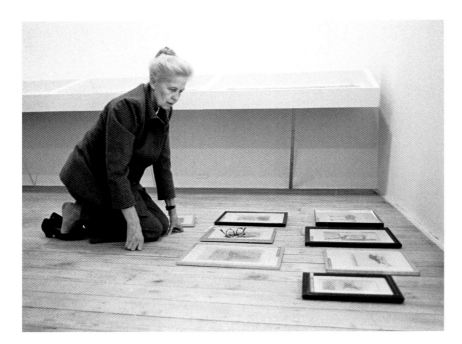
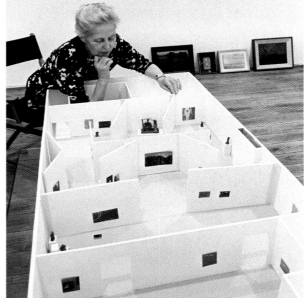

FIGURES 5–6. Dominique de Menil planning the exhibition "Max Ernst: Inside the Sight," Institute for the Arts, Rice University, Houston, 1973.

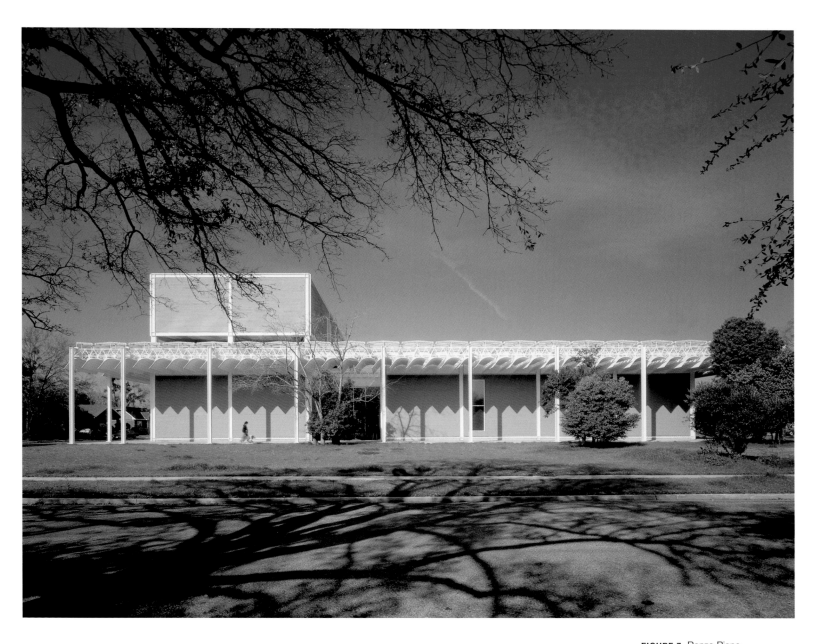

FIGURE 7. Renzo Piano
(b. 1937). The Menil Collection,
Houston, completed 1987.

NOTES

1. John de Menil to Alfred H. Barr Jr., Dec. 9, 1955, Object Files, The Menil Collection, Houston (hereinafter Menil Object Files).

2. Max Ernst's wife, the painter Dorothea Tanning, sent the photograph reproduced here as figure 4 to Dominique de Menil on Feb. 14, 1953. In a letter of the same date, Tanning wrote, "You may like to have this photo, made by Bob Motherwell, of the King driving to the foundry to have himself cast in bronze." Menil Object Files.

3. Dominique de Menil to Pontus Hulten, May 16, 1975, Menil Archives, The Menil Collection, Houston (hereinafter Menil Archives).

4. Ibid.

5. John de Menil to Andy Warhol, Jan. 14, 1969, Menil Object Files.

6. In 1971 the de Menils organized "Some American History" through the Institute for the Arts, Rice University. The exhibition, consisting mainly of work by Larry Rivers, addressed the contentious subjects of African American identity, the history of the slave trade, and racism.

7. John de Menil to Professor Jacques Millot, Feb. 19, 1965, Menil Archives.

8. The de Menils gave works to approximately twenty-five museum and university collections in Europe and in the United States.

9. See Bertrand Davezac, "Ménil et la présente exposition," in *La rime et la raison: Les collections Ménil (Houston–New York)*, exh. cat. (Paris: Éditions de la Réunion des Musée Nationaux, 1984), p. 20.

10. Dominique de Menil, speech on the occasion of receiving the Legion of Honor from Ambassador Emanuel de Margerie, May 16, 1985, Menil Archives.

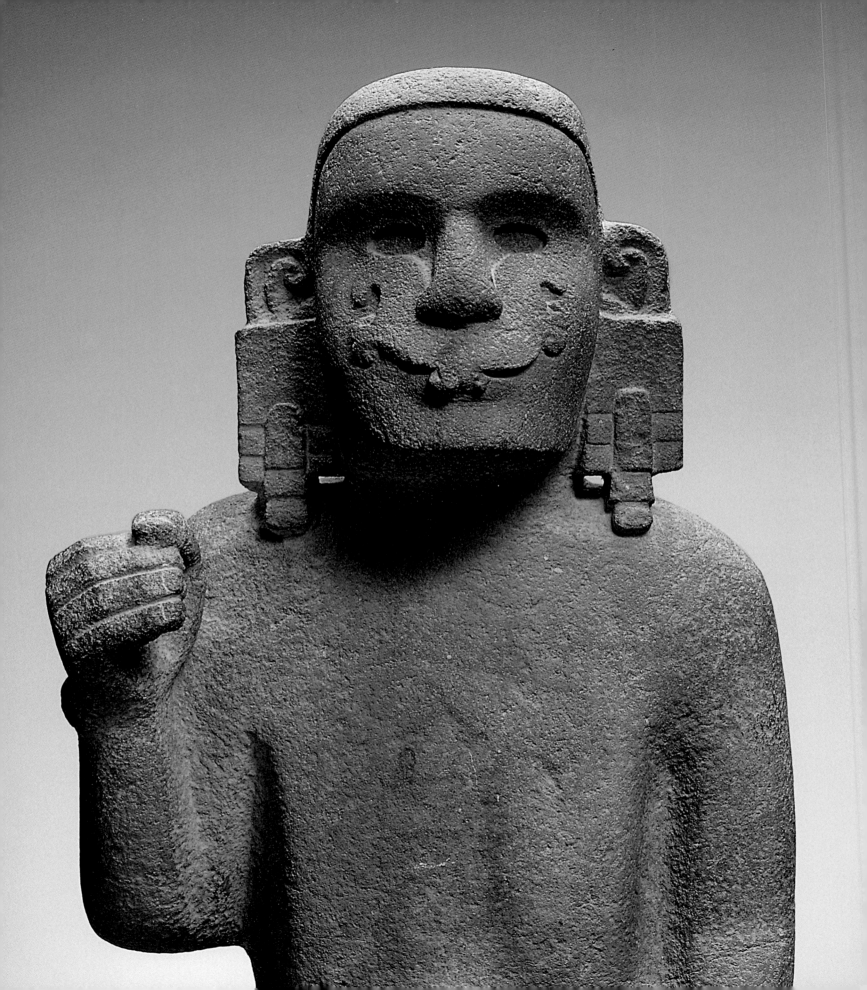

SEEING THE UNSEEN

James Johnson Sweeney and the de Menils

MARCIA BRENNAN

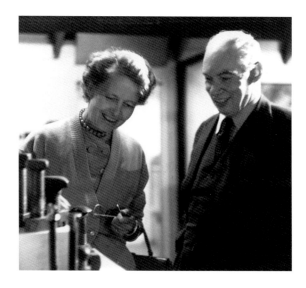

FIGURE 8. Dominique de Menil and James Johnson Sweeney at "Trojan Horse: The Art of the Machine," at the Contemporary Arts Association Houston, 1958.

IN HIS BOOK *Vision and Image: A Way of Seeing* (1967), the critic and museum director James Johnson Sweeney (1900–1986) (figure 8) expressed his longstanding views on the unique role that museums play in contemporary culture. Conjoining a sense of poetic imagination with seasoned curatorial practice, Sweeney observed:

> The key to a lively and vital appreciation of the arts in the fields of collecting and criticism is the willingness to keep doors open, an eagerness to venture into new fields for the sake of the enjoyment which a work of art can bring. William Butler Yeats has expressed the heart of this viewpoint in his statement, "Culture does not consist in acquiring opinions but in getting rid of them" and Plutarch in "Education is not the filling of a pail, but the lighting of a fire."[1]

Significantly, Sweeney's statement resonates strongly with the beliefs and ideals of his friends and patrons John and Dominique de Menil. Employing similar creative metaphors to characterize the encounter with a work of art, Dominique de Menil emphasized the importance of eschewing extraneous information in order to privilege revealing flashes of internal insight. As she once said of Max

OPPOSITE: *Standard Bearer.* Aztec, 1425–1521 (detail). See plate 20, p. 59.

Ernst's visionary Surrealist landscape *Day and Night*, 1941–42 (figure 9), "If you were to ask me the essence of my belief, I would name *Day and Night*. I believe things exist, but we see them only as flashes sometimes. . . . I want just what is within me. . . . Don't ever lose that instant of inspiration. Just put it anywhere so you can find it."[2] In this essay, I will focus on one of the most historically and theoretically significant, yet notably under-examined, aspects of Sweeney's and the de Menils' creative collaborations, namely their complementary adoption of aesthetic philosophies with spiritual overtones. As we shall see, the beliefs they shared guided the practical aspects of their respective collection-building activities, just as they provided an affective means of evoking and exploring invisible worlds.[3]

From 1961 to 1967, Sweeney held the position of director of the Museum of Fine Arts, Houston (MFAH), where John de Menil served as a trustee. Significantly, de Menil was a member of the search committee, and it was he who offered the job to Sweeney.[4] As Dominique Browning noted in a profile essay on the de Menils, "John de Menil had a seat on the board when it undertook the task of finding a director who could handle Mies' [van der Rohe] intimidating open space.

When he heard that James Johnson Sweeney had resigned his post as director of the [Solomon R.] Guggenheim Museum, New York, John de Menil picked up the phone, and within a short time Sweeney was settled in Houston."[5] Prior to this development, Sweeney and the de Menils had moved in overlapping social circles in New York, and the couple had donated artworks by Victor Brauner and Ernst to the Guggenheim during Sweeney's tenure as its director (1952–60).[6]

Correspondence between Sweeney and the de Menils reveals that they enjoyed an especially cordial and professional relationship and held similarly progressive, cosmopolitan views on contemporary art. Once Sweeney officially assumed the museum directorship in Houston, the de Menils generously supported his activities. They not only underwrote his professional expenses, but were vociferous advocates of his various modernist projects and shared his ambitious aspirations for the cultural life of the city of Houston.[7] Perhaps most importantly, both Sweeney and the de Menils maintained an uncompromising commitment to upholding the highest artistic standards, which meant devotion to the smallest curatorial issues. Dominique de Menil later served as a curator and exhibition designer at several Houston institutions

FIGURE 9. Max Ernst (1891–1976). *Day and Night*, 1941–42. Oil on canvas. 44¼ x 57½ in. (112.4 x 146.1 cm). The Menil Collection, Houston, purchased with funds provided by Adelaide de Menil Carpenter.

she and John de Menil helped to create, including the art gallery of the University of St. Thomas, the Institute for the Arts at Rice University (now no longer in existence), and The Menil Collection. She wrote on the subject of hanging exhibitions:

> The beauty of an exhibition is made of lots of little details. It is *a combination of a certain vision with the impeccable revealing.* Every detail has to be perfect. Mies used to say: GOD IS IN THE DETAIL. As to the planning it cannot be done by more than one or two or three people closely working together. *Exhibitions, like architecture,* are the most *undemocratic* activities — you can't do [them] by committee and vote [emphasis in the original].[8]

When it came to building collections, Sweeney and the de Menils focused on issues of quality and eclecticism rather than on a comprehensive or systematic mode of acquisition.[9] Sweeney had adopted this discriminating approach at the Guggenheim, and he openly asserted the value of this position from the very beginning of his association with the MFAH.[10] So, too, the de Menils maintained their focus as they assembled a collection whose strengths lay in the areas of classical,

Byzantine, African, Oceanic, Native American, and modern art. Former medieval curator Bertrand Davezac thus evocatively characterized The Menil Collection as "a set of archipelagoes or islands, in contradistinction to the continental expanse which characterizes the encyclopedic museum."[11]

Their shared emphases on the extraordinary and selective visions of artists, collectors, and curators can be seen as a reflection of Sweeney's and the de Menils' spiritually oriented aesthetic philosophies. In *Vision and Image,* Sweeney wrote that a museum's "basic purpose should be to stimulate the aesthetic responses of its public to a richer, spiritual life, to a fuller enjoyment of the spiritual over the material, of relationships rather than things." He compared art to religious phenomena, claiming that both reveal "the unseen through the seen," just as works of art display the "conception of a macrocosmic unity through an assimilable microcosm."[12] By emphasizing a visible connection between the domains of microcosmic immanence and macrocosmic transcendence, Sweeney promoted an aesthetically oriented, modernist version of the Doctrine of Correspondences found within ancient philosophical formulations of hermetic mysticism. To cite Evelyn Underhill, a popular early twentieth-century writer on mystical practices and ancient

religions, the Doctrine of Correspondences posited an underlying correlation "between appearance and reality, the microcosm of man and the macrocosm of the universe, the seen and the unseen worlds."[13]

In turn, Dominique de Menil presented analogous versions of these concepts in her own writings on art. When commenting on her philosophy of collecting, for example, she emphasized the ineffable qualities of art, which she believed surpasses the explanatory capacities of language. Citing the French poet and critic Charles Baudelaire, whom she greatly admired and whose writings were on her bedside table when she died, she maintained that "art is of all human activities the one that can be least explained. . . . Explanations if they are given remain on the surface. They might tell you something about the artists, but [they] wouldn't tell you why the work is great. That's why artists get so impatient when they are asked to explain their work."[14] At the same time, however, she recognized the evocative power of language. When reflecting on the role of art criticism in the foreword that she contributed to *The Menil Collection: A Selection from the Paleolithic to the Modern Era* (1987), Dominique de Menil observed that "words can be illuminating. They may put you

in a frame of mind that the invisible becomes visible." She proceeded to comment on the ostensibly magical agency that art exerts in contemporary culture, asking, "And what is art if it does not enchant? Art is incantation. Like Jacob's ladder, it leads to higher realities, to timelessness, to paradise. It is the fusion of the tangible and the intangible; the old hierogamy myth — the marriage of heaven and earth."[15] Moreover, much as Sweeney privileged "relationships rather than things," Dominique de Menil remarked that, in museums, "installation was all about how things looked in relation to each other and to the space they inhabited."[16] Thus, both Sweeney and the de Menils conceived the practice of curating as a form of intersubjectivity, a meaningful, multilevel dialogue between viewers, works of art, and the shared spaces in which they meet.

As these various comments suggest, a paradox seems to lie at the heart of the aesthetic and spiritual philosophies that both Sweeney and the de Menils expressed in their writings, and that they implemented practically in their curatorial and collecting strategies. Namely, they maintained that works of art, and the accompanying words that seemingly illuminate these extraordinary objects,

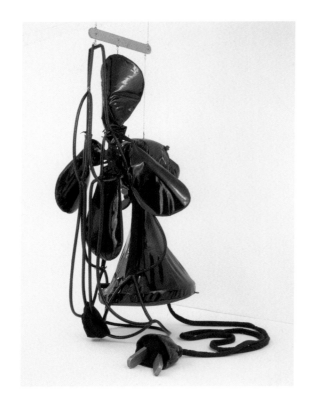

FIGURE 10. Claes Oldenburg (b. 1929). *Giant Soft Fan*, 1966–67. Vinyl filled with foam rubber, wood, metal, and plastic tubing. 120 x 58⅞ x 61⅞ in. (304.8 x 149.5 x 157.2 cm). The Museum of Modern Art, New York, The Sidney and Harriet Janis Collection (2098.1967).

can be instrumental in revealing "the unseen through the seen," thereby providing traces of the unsaid through the said, while shedding light on the unknowable in the domain of the physical.[17] As we shall see, this paradox often took the form of the visible conjunction of opposites into a state of oneness. For Sweeney and the de Menils, this fusion not only encompassed a convergence of the seen and unseen worlds, but also signified the coexistence of the microcosmic and macrocosmic, presence and absence, creation and destruction, modernism and primitivism, historical temporality and archetypal timelessness. The result was a complex oscillation between these various polarities of difference and the constant overcoming of that difference.

The often dramatic pairing of apparent opposites is evident in many of the forty-one artworks that the de Menils donated to the MFAH during Sweeney's tenure, eleven of which have been assembled for the present exhibition. Claes Oldenburg's *Giant Soft Fan, Ghost Version*, 1967 (plate 4, p. 41) is a compelling case in point. A pioneering figure in the Pop Art movement, Oldenburg displays a characteristically humorous and sophisticated grasp of the various — and often

conflicting — impulses underpinning modern consumer culture and their potentially metaphysical resolution within monumental aesthetic forms.[18] In *Giant Soft Fan, Ghost Version*, the artist paradoxically inverted the customary associations between functional subject matter and artistic form by transmuting the shiny, hard, sharp metallic surfaces of an actual working fan into a large-scale sculpture composed of limp white canvas laid atop foam rubber set over a wooden frame. The fan blades are suspended from the museum's ceiling; their gently rounded contours hover aerially, suggesting a miniature windmill.[19] A length of white cord is looped gracefully over the sculpture, lightly draping its monumental bulk in an elegant interlace of practical adornment.

Oldenburg often made multiple versions of his sculptures, utilizing the colorful cloth, vinyl, and plastic materials associated with Pop Art, while simultaneously producing monochromatic models or "ghost versions" of these same objects in white canvas. Referring to the counterpart of the MFAH sculpture, a black vinyl *Giant Soft Fan*, 1966–67 (figure 10), Oldenburg wrote: "There is a black fan and a white one — the theme of opposites in the context of superstition. I have a shiny black fan and

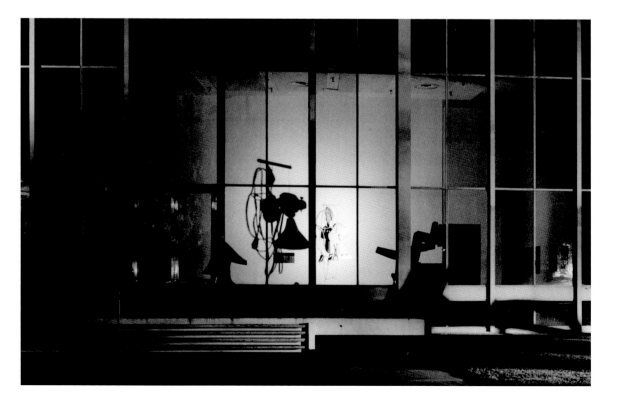

FIGURE 11. Installation view of Claes Oldenburg's *Giant Soft Fan, Ghost Version*, in Cullinan Hall at the Museum of Fine Arts, Houston, in "New Acquisitions, Loans, and Selections from the Museum Collection," June 8–September 24, 1967. Courtesy Museum of Fine Arts, Houston, Archives.

a dry white fan — like the two angels, those winged victories that walk beside you, the white angel and the black angel."[20] Playing on the contrasting themes of darkness and light, fan blades and angel wings, Oldenburg infused objects of everyday life with a poetic quality as he transformed an ordinary desk fan into a hybrid form, part classical muse, part angelic eidolon. Moreover, much like Sweeney and the de Menils, Oldenburg viewed the art object as providing a compelling way to bridge the gap between the material and the spiritual. As the artist wrote in 1966:

> I imitate 1. objects and 2. created objects, for example, signs, objects made without the intention of making "art" and which naively contain a functional contemporary magic. . . . This elevation of sensibility above bourgeois values, which is also a simplicity of return to truth and first principles, will (hopefully) destroy the notion of art and give the object back its power. Then the magic inherent in the universe will be restored and people will live in sympathetic religious exchange with the materials and objects surrounding them. They will not feel so different from these objects, and the animate/inanimate schism [will be] mended.[21]

In this statement, Oldenburg expressed a mystically inflected sense of animism in order to affirm the vital life force that infuses seemingly ordinary, inanimate objects, thereby engendering a sense of enchantment in the quotidian world. In turn, Sweeney reinforced these magical associations in his dramatic display of *Giant Soft Fan, Ghost Version* through the exposed glass curtain wall of the MFAH's Cullinan Hall (figure 11). He aimed a floodlight directly at the sculpture so that, at night, the work was starkly illuminated, casting a dark shadow onto the gallery's back wall for the benefit of nocturnal passers-by. Through these heightened contrasts, Sweeney's theatrical framing conjured a unification of seemingly oppositional themes: shadow and substance, darkness and light, angels and ghosts, and philosophical gravity and playful levity.

John de Menil purchased *Giant Soft Fan, Ghost Version*, from Oldenburg's May 1967 show at the Sidney Janis Gallery, New York, expressly for the MFAH. On May 29, de Menil informed S. I. Morris Jr., then president of the museum's board:

> In the current show at Sidney Janis, Dominique and I reserved the Melting Fan [*sic*] of Claes Oldenberg [*sic*]. We believe Oldenberg is one of the most important American artists of his generation and the fan, monumental in size, is a piece for Cullinan Hall. We were glad to find Jim Sweeney in agreement with us on both points, so we are going ahead with the gift. Our friends and yours most probably will not like it, and the public will perhaps find it difficult at first. Yet, twenty years from now the museum will be proud to own it.[22]

Perhaps the most controversial of all the gifts the de Menils made to the MFAH is the group of mechanical artworks by the Swiss motion sculptor Jean Tinguely that the museum acquired in 1965. In December 1964, John de Menil attended the opening of the "'Méta' Tinguely" exhibition at Alexander Iolas's Paris gallery. Impressed by what he saw, he "alerted Jim [Sweeney] to it and in early January, he confirmed my impression."[23] When Sweeney saw the exhibition, he immediately recognized the exceptional opportunity he had to obtain a representative selection of Tinguely's sculpture.[24] As Sweeney later told Campbell Geeslin, art critic of the *Houston Post*: "In Paris last winter, I was taxiing down the Boulevard St. Germain when throngs pouring into a gallery blocked our way. I hopped out and inched my way in to find the reason for such excitement. It was Tinguely. The show had a unity. It represented ten years of the artist's explorations, a cross-section of his work — not just a single expression. It was the sort of selection a museum should offer to represent a sculptor's efforts and achievements."[25] This initial moment of inspiration was followed by a series of strategic maneuvers and collaborative interactions between Sweeney and John de Menil, all of which provided the tangible means to secure this important, high-profile acquisition for the MFAH.

Shortly after viewing the exhibition, Sweeney learned that the de Menils had already purchased one item from the show, Tinguely's automatic drawing machine *Méta-matic No. 9 (Scorpion)*, 1959, a work that they would later donate to the MFAH as part of the Tinguely ensemble. Sweeney consulted privately with John de Menil regarding the price the collector had paid Iolas for the sculpture. On December 20, 1964, John responded encouragingly: "I checked the price we paid for the Tinguley [*sic*]. It is quite a bit higher than I had told you . . . still unexpensive [*sic*] though and the total should be of the same order of magnitude: in the thirties perhaps, instead of the twenties. Merry Christmas, Jean [de Menil sometimes referred to himself using his French name]."[26] De Menil's allusion to "the total" suggests that, from the outset, he and Sweeney had discussed obtaining the Tinguely show in its entirety for the museum. Supporting this proposition is a document preserved in the exhibition files of the MFAH's archives, a scrap of yellow paper with a brief notation, written in Sweeney's hand: "Tinguely @ Iolas. Buy whole exhibition. Jean de Menil's suggestion."[27] Sweeney immediately telegrammed the de Menils from Paris on January 7: "Agree enthusiastically. If possible take all. Sweenguely."[28] The fictive name Sweeney used to sign off conflates his and Tinguely's surnames in a humorous, even poetic way. As such, it functioned as a playful sobriquet of linguistic unity formed by the dissolution of boundaries between the artist's and the curator's individual identities, creating a new persona. "Sweenguely" also provided Sweeney with a witty pseudonym as he kept de Menil informed about the various transactions with Iolas.

Displaying considerable market acumen, Sweeney actively negotiated with Iolas in order to

leverage an advantageous price for the purchase of the entire show. In a letter to the dealer dated January 30, 1965, the museum director framed their interactions to make it appear as though the idea of acquiring the entire exhibition originated with the Paris gallery, rather than with the de Menils or himself. He credited Bénédicte Pesle — a gallery associate who was also a niece of John de Menil's — with initially suggesting "that it would be good for a Museum to acquire the Tinguely exhibit as an integer."[29] Sweeney concluded by asserting: "What the matter finally turns on is the price. Keeping in mind the common advantages of such a transaction to all of us, what is the lowest price you can ask for the exhibition — exclusive of course of the piece Mr. and Mrs. De [*sic*] Menil have already acquired?"[30] By February 12, Sweeney and Iolas had settled on a mutually satisfactory figure for the nine available sculptures. As part of the agreement, Iolas was to donate Tinguely's *Radio "WNYR" Drawing* to the museum, and the artist himself would later offer an additional piece.[31]

Upon learning of the purchase, Tinguely telegrammed Sweeney directly to express his gratitude and delight. The artist wrote, "Sweeney I am amazed. I congratulate my machines. You make them very happy. I thank you[,] you are wonderful and I am happy to tell you so. Tinguely."[32] Shortly thereafter, Sweeney warmly responded: "You were very kind to cable me as you did from Paris. I was very touched by your message. Actually the gratification is ours — to have what I hope you will agree with me is a good representation of your work and a very proud addition to our Museum Collection."[33] In short, the acquisition of the Tinguely show represented a major coup for everyone involved. With great flourish, Sweeney displayed Tinguely's meta-mechanical sculptures at the MFAH in a one-person show held in the spring of 1965 (figure 13).[34]

Of the twelve Tinguely artworks that Sweeney acquired from Iolas, three are included in the present exhibition: *Méta-Mécanique Relief*, 1954 (plate 5, p. 43), *Bascule*, 1960 (plate 7, p. 45), and *M. K. III*, 1964 (plate 9, p. 47). The imaginative qualities that distinguish *Méta-Mécanique Relief* are especially apparent when the device is plugged in, as the turning wheels of the sculpture's steel wires and painted cardboard forms animate the otherwise stable, mostly enclosed composition. Thus, the artwork becomes a hybrid aesthetic expression, as the activated motion sculpture evokes a mobilized form of painting.[35] In contrast to the delicate kineticism of *Méta-Mécanique Relief*, the actions of *Bascule* and *M. K. III* play on absurdist and erotic associations in humorous parodies of human sexual behaviors. *Bascule* evokes the swinging motions of a scale or seesaw, as the sculpture vigorously rocks back and forth on steel rods and an aluminum pulley. The piece's frenzied actions are further enhanced by the ringing sounds of a brass bell attached to the tip of the sculpture's extended steel wire. *M. K. III* resembles a car, with various steel elements, a steel-pipe section, and iron wheels on tracks set onto a wooden base. Propelled by a rubber belt, a flat belt, and a 110-volt electric motor, the car travels back and forth on tracks, going nowhere.

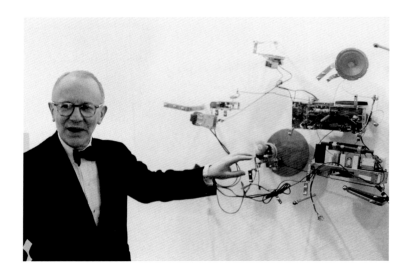

FIGURE 12. John de Menil at a Jean Tinguely exhibition, Alexander Iolas Gallery, New York, 1962.

The sculptor Lee Bontecou also played with sexual metaphors — albeit in a much more intense, threatening way than Tinguely. John de Menil acquired an abstract sculpture of 1962 for the MFAH directly from Bontecou's solo show, held in late 1962 at the Leo Castelli Gallery, New York (plate 11, p. 49).[36] Sweeney greatly admired this piece as well, considering it to be an important contribution to the sculpture collection he hoped to build at the MFAH, whose expansive Cullinan Hall he believed provided a striking display area for dramatically silhouetted three-dimensional forms. As Sweeney declared to his patron, Bontecou's work "is a most important addition to the Collection. Little by little we are heading toward a major sculpture group."[37] Two weeks later, in his formal acknowledgment of the gift, Sweeney stated his appreciation in even more enthusiastic terms, telling de Menil: "One more gift for which the President and the Trustees of the Museum and I are indebted to you — the sculpture by Lee Bontecou. I am particularly glad that the Museum Collection will have this as I feel it is the best I have ever seen by Bontecou."[38]

The appeal of Bontecou's enigmatic sculpture lies in part in the paradoxical associations that arise from the artist's highly suggestive use of materials. The work is composed of welded steel, epoxy, canvas, fabric, and wire, with a saw blade embedded in the gaping hole that appears at the very center. Taken together, the formal elements of this complex, unsettling work seem to coalesce into a kind of creaturely presence, a metaphorical

being with canvas skin set over a skeletal steel frame, its various parts sutured with metal wire in exposed seams. Structurally, this artwork is nothing if not paradoxical, as the metal and canvas appear to be industrially fabricated materials that nonetheless feel raw and are even crudely hand-stitched. Its projecting layers call to mind the aperture of a camera lens, just as they simultaneously suggest a highly unsettling floral form, its clustered canvas "petals" encircling an open, central void. As such, Bontecou's sculpture stands as an intricate, yet ambiguous, configuration of unfolding exterior surfaces and enfolded interior spaces. The saw blade embedded in the provocative dark core evokes a foreboding abyss, as the viewer realizes that a shredding implement is nestled at the sculpture's gaping midpoint. Through this play of ambivalent associations, a shattering hint of destruction emerges as the other face of Bontecou's artistic creation.

A similar set of paradoxical themes can be seen, albeit in very different terms, in Jackson Pollock's abstract imagery. Among the de Menils' many gifts to the museum, Pollock's "drip" painting *Number 6*, 1949 (plate 12, p. 51), is one of the most significant. Dense skeins of black and white paint have been poured, dripped, and otherwise applied to the canvas. These tonal contrasts make the surface appear to jump abruptly between a tangled web of forms and the more disjunctive presence of a fragmented assemblage. The result is an oscillating visual dynamic that constantly hovers between recession and emergence. Underlying

FIGURE 13. Installation view of "Jean Tinguely: Sculptures," April 3–May 30, 1965, Museum of Fine Arts, Houston. Courtesy Museum of Fine Arts, Houston, Archives.

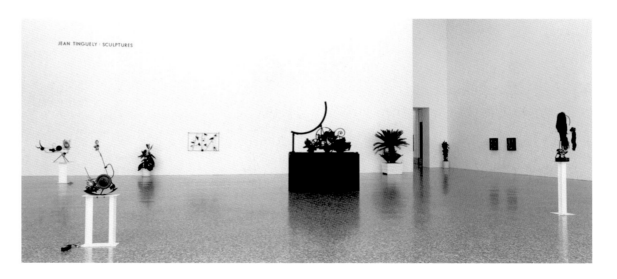

patches of bright yellow, red, orange, blue, and green create an animated interplay of light and color, as these chromatically vibrant areas seem to come from the painting's depths and materialize onto its surface. *Number 6* thus resonates with Sweeney's metaphor of the artwork-as-microcosm, for it can be viewed as a schematic model or painterly sketch of an alternative universe, a miniature cosmos that is revealed through the complex entanglement of dark voids and gleaming sparks of color.

Historically, Sweeney played an important role in Pollock's career. As an advisor to the dealer and collector Peggy Guggenheim, he championed the painter from his first one-person show at Guggenheim's progressive Art of This Century Gallery in November 1943, and he later acquired his *Ocean Greyness*, 1953 (figure 14), for the Guggenheim. The Menil Collection includes several important works by Pollock, spanning different periods of the artist's career, ranging from the shamanically and psychoanalytically evocative *Magic Mirror*, 1941 (plate 13, p. 52), to exquisite examples of Pollock's untitled, monochromatic ink drawings of 1951 (plates 36, 37; pp. 106, 107).[39] In addition, Dominique de Menil helped to acquire the highly enigmatic late abstract work *The Deep*, 1953 (plate 35, p. 105), for the Centre Pompidou, Paris.

Like many prominent collectors and curators of the era, the de Menils and Sweeney assembled extensive collections of ethnographic and modern art, which they did not hesitate to combine jointly in various shows.[40] This program of acquisition and display can be placed within the context of a larger modernist project that sought to bridge the gap between Western and non-Western cultures, between ancient and modern aesthetics, through the elaboration of shared formal and spiritual qualities. Thus, in his installations at the MFAH, Sweeney frequently juxtaposed "primitive" artifacts and ritual objects with canonical modernist paintings and sculptures.[41] He made one such expressive pairing in a showcase exhibition, "Some Recent Accessions," at the MFAH in March and April 1962 (figures 15, 16).[42] In addition to its impressive selection of abstractions by painters such as Pierre Alechinsky, Franz Kline, Robert Motherwell, and Pierre Soulages, Sweeney included a late-nineteenth-century *Ceremonial Feast Bowl* from the Matankor people of the Admiralty Islands (plate 17, p. 56), and a Nafana, Kulango, or Degha *Bedu Mask* from Côte d'Ivoire and Ghana (plate 16, p. 55).[43] As the installation shots and the accompanying catalogue reveal, Sweeney's transcultural design was formally suggestive and quintessentially

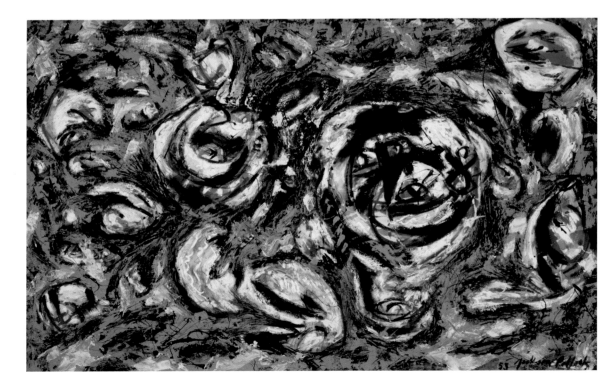

FIGURE 14. Jackson Pollock (1912–1956). *Ocean Greyness*, 1953. Oil on canvas. 57¾ x 90⅛ in. (146.7 x 228.9 cm). Solomon R. Guggenheim Museum, New York (54.1408).

modernist. This reflected a policy, stated the director, of "the broadening of the Collection to embody a variety of works of artistic excellence, rather than the adoption of an historical or documentary approach."[44] During the 1960s, Sweeney consulted with John de Menil on the acquisition of African and Oceanic artworks for the museum's permanent collection, and by early 1965 de Menil was able to declare that "James Johnson Sweeney is building up, with our help, a primitive art collection — African, Oceanic, and Pre-Columbian — at the Museum of Fine Arts in Houston. He now has some remarkable pieces."[45] In support of this goal, the de Menils generously extended an open invitation to the MFAH to borrow pieces from their art collection. De Menil informed Sweeney in February 1963, "You well know that anything we have at home always is available to you when you need it."[46]

In addition to their gifts to the MFAH, in 1965 the de Menils donated an Asante *Kuduo* to the Musée de l'Homme (now the Musée du Quai Branly), Paris (plate 3, p. 15), an institution whose ethnographic holdings the couple greatly admired. Moreover, during the 1960s, John de Menil served as a trustee not only at the MFAH, but also at Nelson A. Rockefeller's Museum of Primitive Art, New York, where the de Menils' collection was dis-

played in 1962. Discussing the couple's holdings in the foreword to the exhibition catalogue, the museum's director, Robert Goldwater, noted that "works of the distant and 'primitive' cultures are to be seen mixed in with the painting and sculpture of the twentieth century. . . . The collection's formulating concept, and its collectors' pleasure, is in the unexpectedly revealed unity, and constancy, of mankind's changing esthetic vision, an attitude and a demonstration that are independent of the accidents of its present temporary housing, because they are inherent in the works themselves."[47] As we have seen, Sweeney installed galleries similarly. He noted that, because Cullinan Hall was specifically designed to receive objects of a wide historical and geographical range, works from the Egyptian Middle Kingdom would be "placed next to European gothic, pre-Cortez Mexican, African, and Oceanic" pieces, to form a display that completed itself "with the most recent contemporary artistic work of Paris and New York." Above all, Sweeney believed that emphasizing the formal connections linking such diverse objects and creating individual points of interest were most effective in guiding viewers through a display. "The sculptural rhythms of a ceremonial bowl from the Admiralty Islands, for example," he wrote, "can be

made to echo the linear rhythms of a painting by Robert Motherwell."[48]

Another de Menil gift to the MFAH, the monumental Matankor *Ceremonial Feast Bowl* (plate 17, p. 56), measures over four feet in width, including the handles. Such vessels had multiple practical and ceremonial uses involving cooking, serving, and storage. The handles, which are separately carved elements attached to the main body of the wooden bowl, feature the highly abstracted forms of either a lizard or a crocodile perching within an openwork pattern of spiraling concentric circles. In Pacific cultures, such reptilian iconography symbolizes the sacred presence of an ancestor spirit. This spirit evokes associations of life and death, seemingly oppositional themes contained within an integrated sphere of being. In turn, this thematic convergence is elegantly mirrored in the bowl's unified circular forms.[49]

Notably, a *Bedu Mask* (plate 16, p. 55) was the first gift that the Menils gave to the MFAH under Sweeney's directorship. As John de Menil wittily remarked to Sweeney in the letter formally announcing the gift, "This will be our first contribution to the primitive art collection which you want to build and which you got off to such a beautiful start with the Sepik River Alligator you brought out of his swamps for the Jones Foundation to shoot" (figure 17; the Houston Endowment, Inc., founded by Mr. and Mrs. Jesse H. Jones, supported the

acquisition of this sculpture, which in fact depicts a crocodile). In the same letter, the collector explained the symbolic significance of the mask's highly abstract iconography: "[The] Mask represents, in an abstract fashion, the head and horns of an antelope surmounted by a huge disk symbolizing the sun. On the reverse side of the lower portion, there is a ridged arch which rested on the head of the carrier and the side of this lower portion is perforated for attaching a net which covered the head."[50] According to the African art scholar René A. Bravmann, the nocturnal Bedu masked dances of West Africa take place over a one-month period during late November and most of December, which corresponds to the harvest season associated with the winter solstice. The performance of the dance marks a time of celebration and the conferring of communal and individual blessings for fertility, healing, social protection, and the prevention of misfortunes.[51]

Similar themes are associated with the *Molo Mask* from Burkina Faso (plate 18, p. 57),[52] which the de Menils donated in memory of Dr. Jermayne MacAgy. MacAgy, who had been a highly influential director of Houston's Contemporary Arts Association (renamed the Contemporary Arts Museum), after which she chaired the art department of the University of St. Thomas, Houston, had died unexpectedly in early 1964.[53] This dance mask, along with an eighteenth- or early nineteenth-

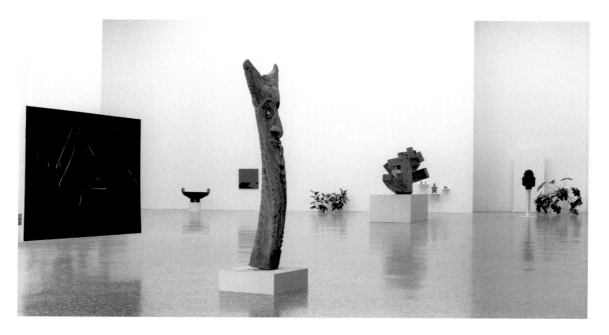

FIGURES 15–16. Installation views of "Some Recent Accessions," March 8–April 9, 1962, Museum of Fine Arts, Houston. Courtesy Museum of Fine Arts, Houston, Archives.

century Dogon *Ceremonial Trough* in the form of an ark (plate 19, p. 58), was part of a group of six African pieces that the de Menils gave to the MFAH in 1964. Much like the African dance mask discussed above, the Dogon ark is thought to have been used by farmers to obtain spiritual protection for their crops. The symbolic forms on the vessel connote a mythic iconography relating to first ancestors. According to the African art scholar Kate Ezra, such wooden vessels "have been interpreted as representations of the mythic ark that descended from heaven to reorganize and populate the world. . . . In addition to the eight original ancestors of mankind, the ark also contained everything that would be essential to life on earth."[54]

These objects from the African continent share themes that reference the spiritual nature of human origins, the enduring presence of ancestor figures, and the continuation of the life cycle. All bespeak the charged status of the artwork as a tangible site for the convergence of multiple temporal dimensions — as a meeting point for a union of heaven and earth — or, as Sweeney put it in *Vision and Image*, for facilitating "the realization of the unseen through the seen."[55] In this text, Sweeney also emphasized the atavistic and "timeless" qualities of artistic production, which he saw as stemming from "that spirit which relates the artist, whether he is conscious of it or not, to his earliest ancestors."[56] Dominique de Menil made

similar thematic connections, although she posited an inverted hierarchy that placed "primitive" artists above modern ones in their ostensible ability to access primal archetypal powers. In the introduction to the Museum of Primitive Art catalogue devoted to her collection, she observed about "primitive" art that "what could never have been written is there, all the dreams and anguishes of man. The hunger for food and sex and security, the terrors of night and death, the thirst for life and the hope for survival."[57]

Despite their important historical and cultural differences, the iconography of the African and Oceanic pieces collectively references leitmotifs of life and death, cycles of creation and destruction in humankind's journey between the earthly and heavenly realms. Another of the de Menils' gifts to the MFAH, an Aztec *Standard Bearer* carved in volcanic stone, 1425–1521 (plate 20, p. 59), evokes similarly reciprocal associations between the sacred status of transitional figures and the transitional status of sacred figures. This work most likely depicts an agricultural deity engaged in a ceremonial offering. Such standard bearers often served as guardian figures placed at intermediary points of passage within a temple complex, such as stairways and entrances. The butterfly-shaped motif appearing directly beneath the figure's nose is an ornamental mask that signifies a connection with the gods of drunkenness and the fermented

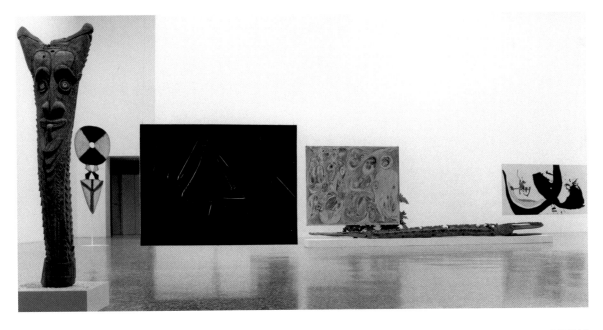

drink *pulque*.[58] Such allusions to sacrality, fertility, and intoxication all call to mind transitional states of consciousness, here somewhat paradoxically embodied in the restrained, upright stone representation of a deity.

For both Sweeney and the de Menils, such artworks provided a vivid demonstration of what they saw as the interwoven — if, to today's audiences, ideologically fraught — relationship between primitivist, shamanist magic and canonical twentieth-century modernism. Sweeney directly associated the negotiation between magical and mundane modes of consciousness with the relation between ancient and modern perspectives. He asserted in *Vision and Image*:

> Here we have not only a hint that the "magic" in the visual arts comes about through the dual senses in which we must accept both terms, *vision* and *image*, so closely tied up with the visual arts, but also another possible link between the attitude of the contemporary artist and connoisseur, and that of the arts of the distant past. . . . In earlier times and among native people, the so-called "primitives," . . . belief was the foundation of seeing. And in contemporary art, today, "believing is seeing," rather than seeing is believing.[59]

Thus, for Sweeney, the juxtaposition of modern and "primitive" artworks served as an affective means for linking twentieth-century audiences to ancient forms of knowledge. William A. Camfield —

a noted historian of modernism who was close to the de Menils over many decades — similarly noted the couple's conception of aesthetics as a tangible affirmation of numinous ideals, an instrumental modality for making the unseen seen. He observed that "Dominique's emphasis on her perceptions of quality and spiritual affinities across time and cultures was a constant in her exhibitions at [the University of] St. Thomas. I think it was not only her personal conviction, but a natural means for her to employ to open the eyes and minds and hearts of a Catholic audience to presences previously unsuspected."[60]

Ultimately, Sweeney and the de Menils framed their respective cultural contributions as a kind of devotional act, a practical cultivation of shared ideals, of "things in which we believe," as John de Menil put it.[61] This phrase is richly apposite in its paradoxical significations, as it unites the physicality of "things" with the ethereality of commonly held "beliefs." This vision provided Sweeney and the de Menils with a compelling means for presenting judgments of aesthetic quality as mutual acts of faith. In the process, intangible ideals served as a foundational basis for the very material practices of art acquisition, curation, and collection-building. As we have seen, for both Sweeney and the de Menils, the project of making invisible worlds visible did not involve accumulating individual pieces meant to serve as representative placeholders within a comprehensive historical scheme. Or, to return to Sweeney's reference to Plutarch, for this threesome, works of art did not constitute individual

FIGURE 17. *Crocodile.*
Papua New Guinea, 1900–50.
Wood and paint. 15½ x 275 x 14 in. (39.4 x 698.5 x 35.6 cm).
Museum of Fine Arts, Houston;
Gift of Houston Endowment, Inc. (61.46).

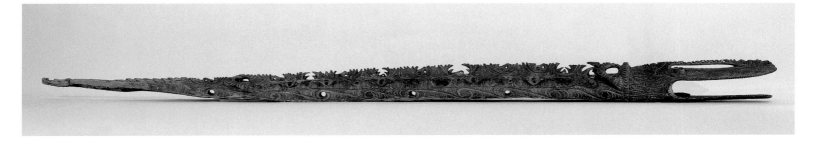

drops collected merely for the sake of filling a pail. (Here, one cannot help but note Sweeney's classic gesture of deploying a rhetorically skillful paradox, as he evoked a venerable ancient writer in order to advocate an experimental engagement with avant-garde art.) Instead, Sweeney and the de Menils repeatedly characterized their spiritually oriented aesthetic practices as activities akin to tending a flame. The result was a particularly vivid form of fire magic, a blaze that sometimes proved to be socially and culturally incendiary, just as it always remained unfailingly, aesthetically radiant.

My thanks go to Alison de Lima Greene for her kindness and assistance in making object files accessible at the MFAH and to Lorraine Stuart, MFAH archivist, for permission to quote from the materials contained within these primary sources. Dr. Karel Arnaut of Ghent University provided expert consultation regarding the Bedu mask. At The Menil Collection, Geri Aramanda, Mary Kadish, Laureen Schipsi, and Michelle White all contributed valuable research assistance and helpful editorial suggestions. Susan F. Rossen of the Art Institute of Chicago provided superb copy-editing. This essay has also benefited from the careful reading and insightful comments of William A. Camfield, Leo Costello, and Kristina Van Dyke, extremely generous colleagues to whom, here and elsewhere, I owe a warm debt of gratitude.

NOTES

1. James Johnson Sweeney, *Vision and Image: A Way of Seeing* (New York: Simon and Schuster, 1967), p. 119.
2. Dominique de Menil's comments were recorded in a memo by Carol Mancusi-Ungaro dated Aug. 19, 1997. A copy can be found in the Menil Archives, The Menil Collection, Houston (hereinafter Menil Archives).
3. These themes represent the subject of a book I am currently writing, *Curating Consciousness: Mysticism and the Modern Museum* (forthcoming from MIT Press).
4. For an account of the institutional history of the MFAH, with an emphasis on Sweeney's role as director, see Toni Ramona Beauchamp, "James Johnson Sweeney and the Museum of Fine Arts, Houston: 1961–1967," M.A. thesis, University of Texas, Austin, 1983.
5. Dominique Browning, "Dominique in Full Bloom," *Town & Country* (Feb. 1984), p. 219.
6. Ann Holmes, "The Art World of Director James Sweeney," *Zest Magazine, Houston Chronicle* (Dec. 3, 1961), p. 1. I am grateful to Lorraine Stuart for providing this reference.
7. An example of John de Menil's efforts to publicize Sweeney's contributions to Houston's cultural life can be found in a letter the collector wrote to the *Swiss Air Gazette*, in response to "Metropolis U.S.A.," a story the magazine had recently published. "You make no reference whatsoever to our rather remarkable cultural development. We have a museum built partly by Mies van der Rohe and directed, since a little over a year ago, by James Johnson Sweeney, one of the most famous museum directors, nationally and internationally." See John de Menil to *Swiss Air Gazette*, Geneva,

Nov. 6, 1962, Records of the Office of the Director, James Johnson Sweeney, Correspondence (RG2: 3:1), Museum of Fine Arts, Houston (hereinafter MFAH Director Records). It should also be noted that, more than twenty years later, Dominique de Menil asked the art historian William A. Camfield to investigate the status of Sweeney's archival papers, particularly whether Sweeney had made arrangements for these documents to be deposited at a specific institution, and to express the Menil Foundation's interest in discussing this matter with Sweeney. See William A. Camfield to Walter Hopps and to Dominique de Menil, Sept. 25 and 26, 1985, respectively, Menil Archives. To date, Sweeney's papers remain largely with the Sweeney family.

8. Dominique de Menil, Sept. 8, 1969, Menil Archives. Regarding Dominique de Menil's curatorial activities, see William A. Camfield, "Dominique de Menil: 1908–1997," *Cite* 40 (Winter 1997–98), pp. 10–11; and Pamela G. Smart, "Sacred Modern: An Ethnography of an Art Museum," Ph.D. diss., Rice University, Houston, 1997.

9. Regarding the intellectual histories and ideological formations underpinning these distinctive modes of art collecting, see Carol Duncan and Alan Wallach, "The Museum of Modern Art as Late Capitalist Ritual: An Iconographic Analysis" (1987), in *Grasping the World: The Idea of the Museum*, ed. Donald Preziosi and Claire Farago (Burlington, Vt.: Ashgate, 2004), pp. 483–99; and Susan Stewart, *On Longing: Narratives of the Miniature, the Gigantic, the Souvenir, the Collection* (Durham, N.C.: Duke University Press, 1993).

10. Sweeney described his method of collection-building at the Guggenheim as being based on "selectivity rather than collectivity." See his introduction to *The Solomon R. Guggenheim Museum* (New York: Solomon R. Guggenheim Museum, 1959), n.p. For a statement on his collecting priorities at the MFAH, see "Just What I Like," *Newsweek* (Jan. 23, 1961), p. 60.

11. See Bertrand Davezac, "Ménil et la présente exposition," in *La rime et la raison: Les collections Ménil (Houston–New York)*, exh. cat. (Paris: Éditions de la Réunion des Musées Nationaux, 1984), p. 18.

12. Sweeney (note 1), pp. 112, 33, 22.

13. Evelyn Underhill, *Mysticism: A Study in the Nature and Development of Man's Spiritual Consciousness* (1911; New York: E. P. Dutton, 1930), p. 191. For Underhill's elucidation of the principles of hermetic mysticism, see especially pp. 184–93. For an insightful analysis of Underhill's comparative discussions of mysticism, see Jeffrey J. Kripal, *Roads of Excess, Palaces of Wisdom: Eroticism & Reflexivity in the Study of Mysticism* (Chicago: University of Chicago Press, 2001).

14. Dominique de Menil, undated notes, Menil Archives.

15. Dominique de Menil, "Foreword," in *The Menil Collection: A Selection from the Paleolithic to the Modern Era* (New York: Harry N. Abrams, 1987), pp. 7–8.

16. Dominique de Menil, as quoted in Smart (note 8), p. 4.

17. For nuanced theoretical discussions of these concepts, see Elliot R. Wolfson, *Language, Eros, Being: Kabbalistic Hermeneutics and Poetic Imagination* (New York: Fordham University Press, 2005); and idem, *Alef, Mem, Tau: Kabbalistic Musings on Time, Truth, and Death* (Berkeley: University of California Press, 2006).

18. For an analysis of the paradigms of commodification and consumption in Pop Art, see Cécile Whiting,

"Shopping for Pop," in *A Taste for Pop: Pop Art, Gender, and Consumer Culture* (New York and Cambridge, Eng.: Cambridge University Press, 1997), pp. 7–49.

19. Given the sculpture's formal and symbolic qualities, *Giant Soft Fan, Ghost Version*, can be seen as an extension of Oldenburg's work of the previous year, when he experimented with an Airflow series that played on themes of machine engines, wind tunnels, and exhaust systems. For a period review of Oldenburg's Airflow series, see "In the Galleries: Claes Oldenburg," *Arts* 40 (May 1966), p. 57.

20. Claes Oldenburg, as quoted in *The Museum of Fine Arts, Houston: A Guide to the Collection* (Houston: Museum of Fine Arts, 1981), p. 172, no. 283. Regarding the darker and more unsettling associations ascribed to the black-vinyl fan, Oldenburg noted, tongue-in-cheek, "My romance with a fan. My romance with a Satanic vinyl fan. I take my appliances to bed with me." See Claes Oldenburg, "America: War & Sex, Etc.," *Arts Magazine* 41 (Summer 1967), p. 35.

21. Oldenburg, as quoted in Gene Baro, "Claes Oldenburg, or the Things of This World," *Art International* 10 (Nov. 1966), p. 42.

22. John de Menil to S. I. Morris Jr., May 29, 1967, Registrar's files, Museum of Fine Arts, Houston (hereinafter MFAH Registrar's files). As Ann Holmes later noted, "The de Menils gave their last gift, Claes Oldenburg's *Giant Soft Fan,* to the MFA the year of Sweeney's departure. From then on they would give some money, service on the board, and nothing else." See Browning (note 5), p. 220.

23. John de Menil to Edward Rotan, Feb. 22, 1965, MFAH Director Records.

24. An expanded version of this show, "Méta II," opened the following March at Alexander Iolas Gallery, New York. The later exhibition represented a collaborative venture between the New York gallery and the Dwan Gallery of Los Angeles. For a complete list of the exhibited works, see Pontus Hulten, *Jean Tinguely: A Magic Stronger than Death* (New York: Abbeville, 1987), p. 357.

25. James Johnson Sweeney, as quoted in Campbell Geeslin, "Museum Buys 12 Sculptures by Swiss Artist," *Houston Post* (Feb. 25, 1965), sec. 5, p. 19.

26. John de Menil to Sweeney, Dec. 20, 1964, MFAH Director Records.

27. This document can be found in the exhibition file for "Jean Tinguely: Sculptures" (Apr. 3–May 30, 1965), Archives, Museum of Fine Arts, Houston (hereinafter MFAH Archives).

28. Western Union telegram from Sweeney to John and Dominique de Menil, Jan. 7, 1965, in ibid.

29. Sweeney to Alexander Iolas, Jan. 30, 1965, in ibid. Bénédicte Pesle later confirmed to the de Menils that she had suggested to Sweeney that "the show should be bought at once as an ensemble." See Pesle to the de Menils, Jan. 14, 1965, Menil Archives. I am grateful to William Middleton for confirming the family relationship between Pesle and the de Menils (based on a telephone interview that Middleton conducted with Pesle on Mar. 29, 2004). Middleton to author, Jan. 24, 2005.

30. Sweeney to Iolas, Jan. 30, 1965, in Tinguely exhibition file (note 27).

31. See the correspondence between Iolas and Sweeney, Feb. 12, 17, and 22, 1965, in ibid.

32. Western Union telegram from Jean Tinguely to Sweeney, Feb. 1965, in ibid.

33. Sweeney to Tinguely, Mar. 4, 1965, in ibid.

34. See James Johnson Sweeney, "Jean Tinguely," in *Jean Tinguely: Sculptures*, exh. cat. (Houston: Museum of Fine Arts Houston, 1965), n.p.

35. Regarding Tinguely's sculpture, see especially Christina Bischofberger, et al., *Jean Tinguely: Catalogue Raisonné: Sculptures and Reliefs 1954–1968* (Küsnacht and Zürich: Galerie Bruno Bischofberger, 1982); and Hulten (note 24).

36. The exhibition garnered mixed responses. See Michael Fried's pointedly critical "New York Letter" in *Art International* 6 (Dec. 1962), pp. 57–58; Dore Ashton's review in *Arts and Architecture* 80 (Jan. 1963), p. 5; and *Artnews* 61 (Jan. 1963), p. 12. In his favorable notice in *Arts Magazine* 37 (Jan. 1963), p. 44, Donald Judd noted the ambivalent associations of Bontecou's sculpture: "It is a minatory object, seemingly capable of firing or swallowing. The image extends from something as social as war to something as private as sex, making one an aspect of the other." For more recent accounts of Bontecou's work, see Elizabeth A. T. Smith, Ann Philbin, et al., *Lee Bontecou: A Retrospective* (New York: Harry N. Abrams, 2003); and Calvin Tomkins, "Missing in Action," *The New Yorker* (Aug. 4, 2003), pp. 36–43.

37. Sweeney to John de Menil, Dec. 15, 1962, MFAH Registrar's files.

38. Sweeney to John de Menil, Dec. 28, 1962, in ibid.

39. For a discussion of *The Magic Mirror*, see Walter Hopps, "*The Magic Mirror* by Jackson Pollock," in *The Menil Collection* (note 15), pp. 254–61.

40. Sweeney had a long-standing interest in African art. For The Museum of Modern Art, New York, he assembled the spring 1935 exhibition "African Negro Art," one of the first public displays of this material in the United States, and authored the accompanying catalogue. Sweeney also contributed an introduction to *African Folktales and Sculpture*, ed. Paul Radin (New York: Pantheon Books, 1952), pp. 3–18.

41. As Suzanne Preston Blier incisively observed, the use of the terms "tribal" and "primitive" to describe African art is highly problematic, given that these descriptions contribute to promulgating an erroneous sense of decontextualization and dehistoricization, as well as promoting a "mythic identity [through] the enduring trope (misnomer/misconception) of the 'primitive.'" See Suzanne Preston Blier, "Perceptions and Misperceptions: The Identity of African Art," in *The Art of Identity: African Sculpture from the Teel Collection*, exh. cat. (Cambridge, Mass.: Harvard University Art Museums Gallery Series, 1997), pp. 7–8. For a historical overview of the cultural debates and controversies surrounding primitivism, see Jack Flam and Miriam Deutch, eds., *Primitivism and Twentieth-Century Art: A Documentary History* (Berkeley: University of California Press, 2003).

42. Lucy Lippard provided a related discussion of the links that were perceived between African and modern art during this period, noting that "familiarity with contemporary abstract art has accustomed us to [African art's] subtleties. . . . The greatest lesson primitive sculpture had to teach the European artist may have been the ability of abstract and geometric forms to convey emotional force." Lippard's article "Heroic Years from Humble Treasures: Notes on African and Modern Art" (1966) is reprinted in a volume of her collected writings, *Changing: Essays in Art Criticism*

(New York: E. P. Dutton, 1971), pp. 35–47. Lippard was inspired to write the article after viewing two contemporaneous exhibitions in Houston, Sweeney's monumental "The Heroic Years: Paris 1908–1914" at the MFAH, and a display of African artworks entitled "Humble Treasures," which Dominique de Menil assembled at the art gallery of the University of St. Thomas.

43. Dr. Karel Arnaut of Ghent University observed that comparable Bedu masks — examples of which can be found in the collections of the Detroit Institute of Arts; Metropolitan Museum of Art, New York; Staatliches Museum für Völkerkunde, Munich; and Musée du Quai Branly, Paris — represent a category of works that entered important Western art collections during the early 1960s, where they were highly valued for their "very 'abstract' (modern) and 'mysterious' (traditional/African)" qualities. See Dr. Karel Arnaut, email message to Kristina Van Dyke, Sept. 15, 2006, Object Files, The Menil Collection, Houston (hereinafter Menil Object Files).

44. James Johnson Sweeney, *Some Recent Accessions*, exh. cat. (Houston: Museum of Fine Arts, 1962), n.p.

45. John de Menil to Professor Jacques Millot, Paris, Feb. 19, 1965, Menil Archives.

46. John de Menil to Sweeney, Feb. 22, 1963, MFAH Director Records (RG2: 3:1).

47. Robert Goldwater, "Foreword," in *The John and Dominique de Menil Collection*, exh. cat. (New York: Museum of Primitive Art, 1962), n.p.

48. James Johnson Sweeney, "Le Cullinan Hall de Mies van der Rohe, Houston," *L'Oeil* 99 (Mar. 1963), pp. 38, 40, 82.

49. For this work, see *The Museum of Fine Arts, Houston* (note 20), pp. 216–17, no. 349.

50. John de Menil to Sweeney, Feb. 20, 1962, MFAH Registrar's files.

51. See René A. Bravmann, *Islam and Tribal Art in West Africa* (London and New York: Cambridge University Press, 1974), pp. 113–14. For a general discussion of the spiritual and artistic qualities of African dance masks, see Bérénice Geoffroy-Schneiter, *Tribal Arts: Africa, Oceania, Southeast Asia* (New York: Vendome Press, 2000), pp. 85–119.

52. For a related discussion of Bobo masks, see Christopher Roy, *Art of the Upper Volta Rivers* (Meudon, France: Alain and Françoise Chaffin, 1987), pp. 328–38.

53. One of MacAgy's best-known exhibitions, "Totems Not Taboo," combined "primitive" and modern art. The show was organized by the Contemporary Arts Association Houston, and held at the MFAH in 1959, prior to Sweeney's arrival.

54. Kate Ezra, *Art of the Dogon: Selections from the Lester Wunderman Collection*, exh. cat. (New York: Metropolitan Museum of Art and Harry N. Abrams, 1988), p. 101.

55. Sweeney (note 1), p. 33.

56. Ibid., p. 53.

57. Dominique de Menil, "Introduction," in *The John and Dominique de Menil Collection* (note 47), n.p.

58. For a brief description of this work, see Janet Landay, *The Museum of Fine Arts, Houston, Visitor Guide* (Houston: Museum of Fine Arts; New York: Scala Publishers, 2000), p. 279, no. 9.21.

59. Sweeney (note 1), p. 30.

60. William A. Camfield to author, Aug. 1, 2006.

61. John de Menil to Alfred H. Barr Jr., Dec. 9, 1955, Menil Object Files.

PLATE 4. Claes Oldenburg (b. 1929). *Giant Soft Fan, Ghost Version*, 1967.
Canvas, wood, and foam rubber. 96 x 54¼ x 73 in. (243.8 x 137.7 x 185.4 cm).

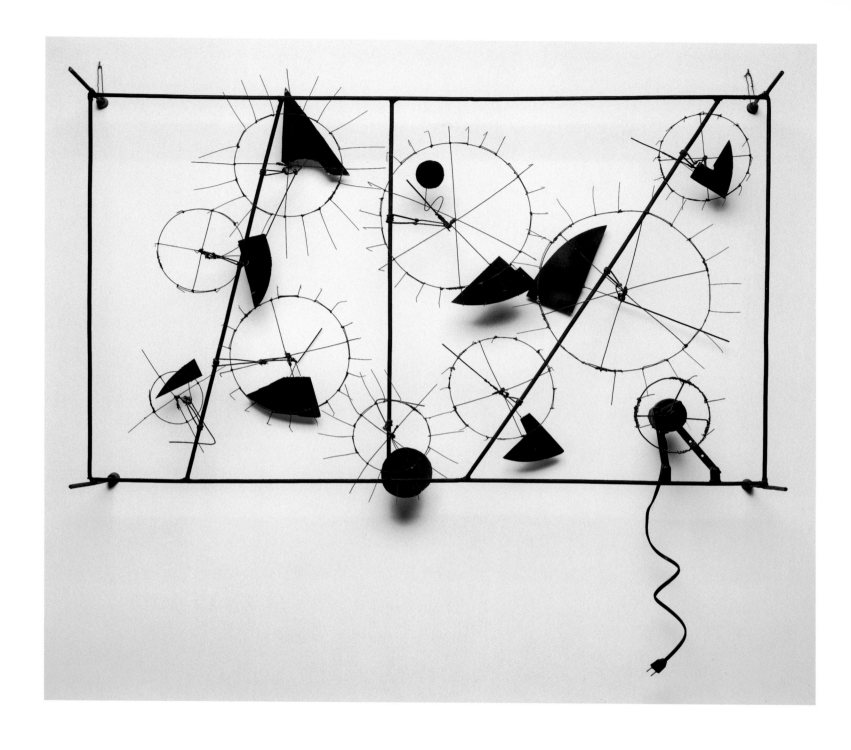

PLATE 5. Jean Tinguely (1925–1991). *Méta-Mécanique Relief*, 1954.
Steel-tube frame, steel wire, painted cardboard, and electric motor. 33½ x 55⅛ x 14⅛ in. (85.1 x 140 x 35.9 cm).

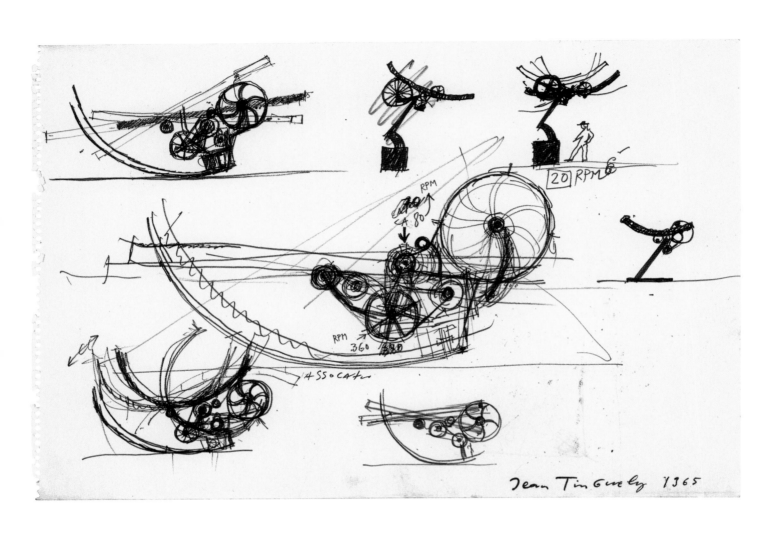

PLATE 6. Jean Tinguely (1925–1991). *Drawing for Bascule #5*, 1965.
Pentel pen and ink on paper. 12 x 17⅞ in. (30.5 x 45.4 cm).

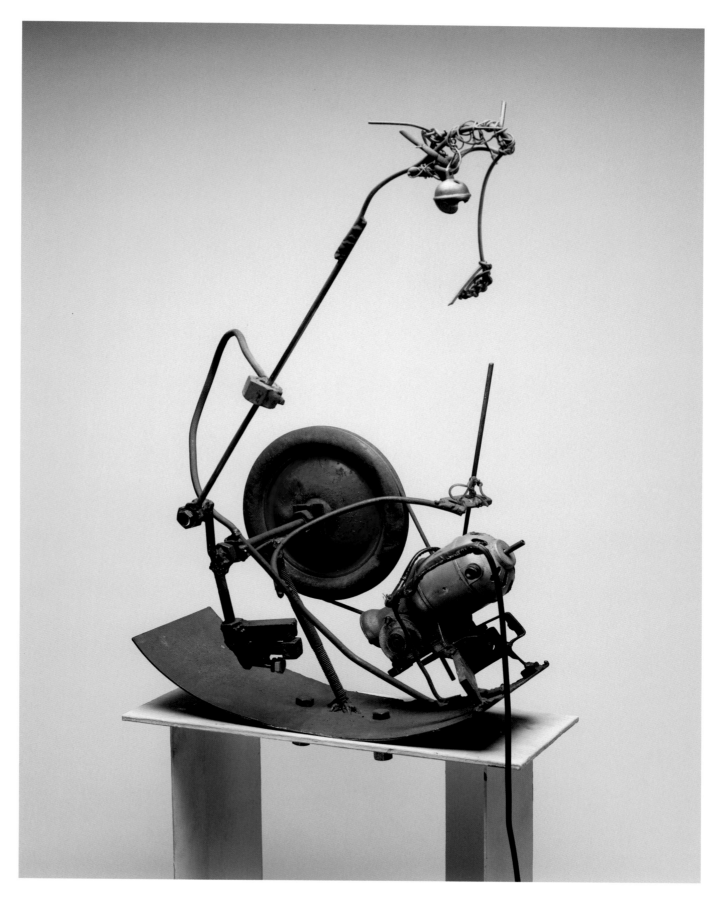

PLATE 7. Jean Tinguely (1925–1991). *Bascule*, 1960.
Steel rods, steel wire, aluminum pulley, brass bell, round rubber belt, and electric motor. 32 x 18 x 14 in. (81.3 x 45.7 x 35.6 cm).

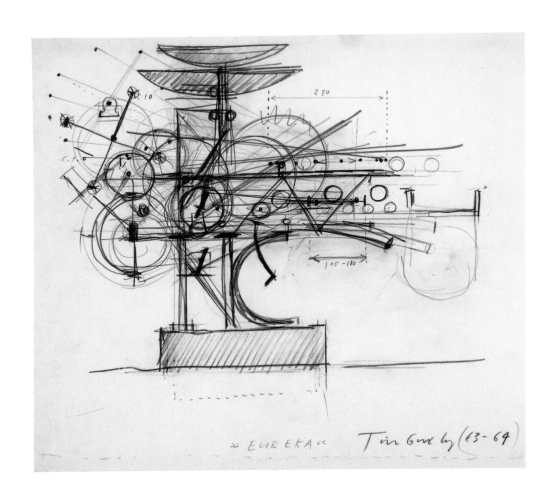

PLATE 8. Jean Tinguely (1925–1991). *Sketch for Eureka*, 1963.
Pencil and ink on paper. 9¾ x 13¾ in. (24.8 x 34.9 cm).

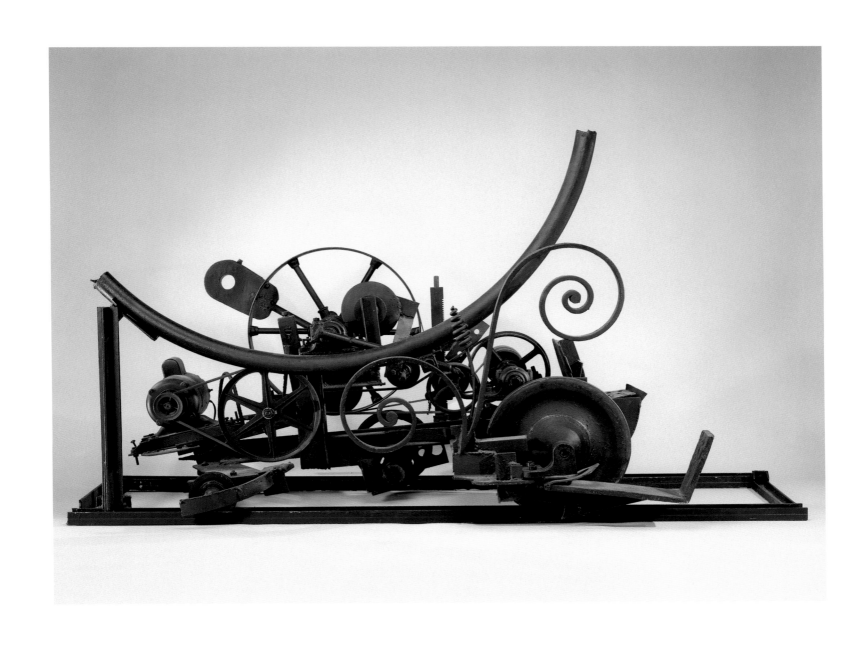

PLATE 9. Jean Tinguely (1925–1991). *M. K. III*, 1964.
Steel, steel-pipe section, iron wheels, rubber V-belt, flat belt, and electric motor. 36¼ x 82⅛ x 38½ in. (92.1 x 209.6 x 97.8 cm).

PLATE 10. Lee Bontecou (b. 1931). *Untitled*, 1963.
Graphite on muslin. 36⅛ x 36¼ x 1 in. (91.6 x 92 x 2.5 cm).

THE MENIL COLLECTION, HOUSTON, GIFT OF ADELAIDE DE MENIL CARPENTER

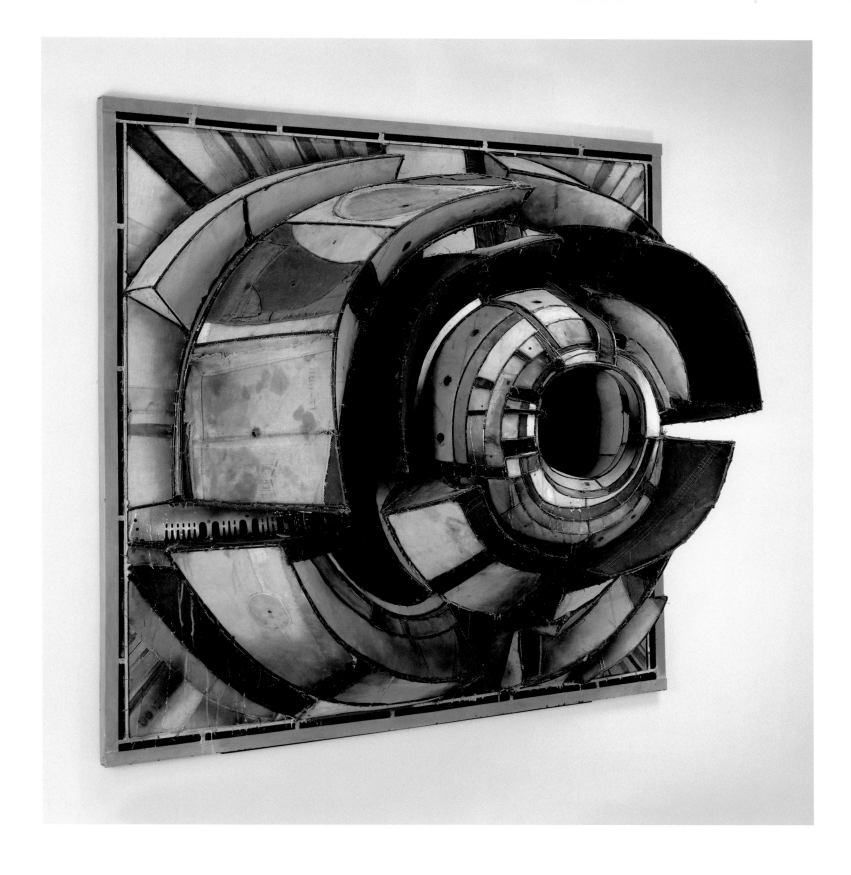

PLATE 11. Lee Bontecou (b. 1931). *Untitled*, 1962.
Welded steel, epoxy, canvas, fabric, saw blade, and wire. 68 x 72 x 30 in. (172.7 x 182.9 x 76.2 cm).

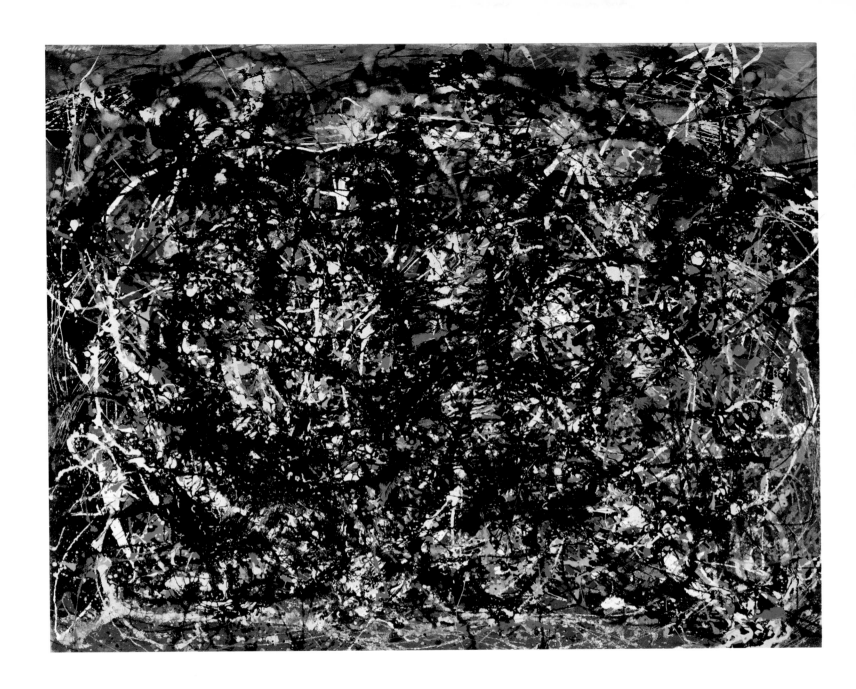

PLATE 13. Jackson Pollock (1912–1956). *The Magic Mirror,* 1941.
Oil, granular filler, and glass fragment on canvas. 46 x 32 in. (116.8 x 81.3 cm).

THE MENIL COLLECTION, HOUSTON

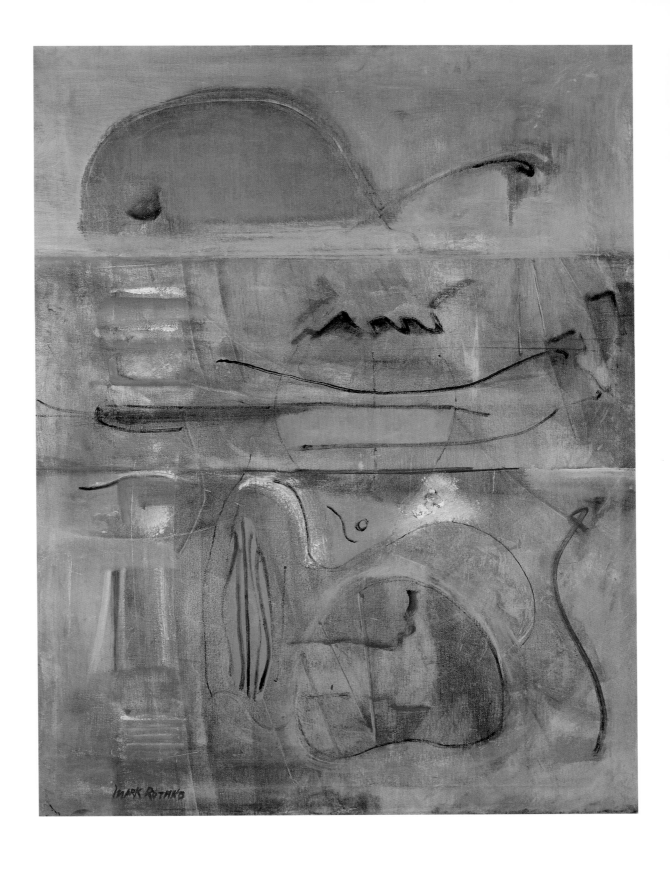

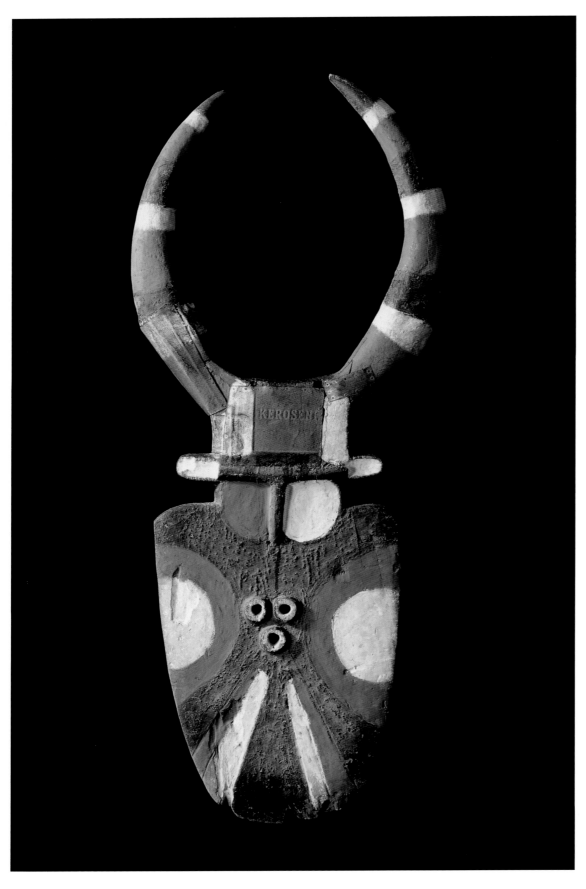

PLATE 15. *Bedu Mask*. Côte d'Ivoire and Ghana; Nafana, Kulango, or Degha, 1940–50.
Wood with paint and metal cut from kerosene tank. 62 x 19¾ x 3 in. (157.5 x 50.2 x 7.6 cm).

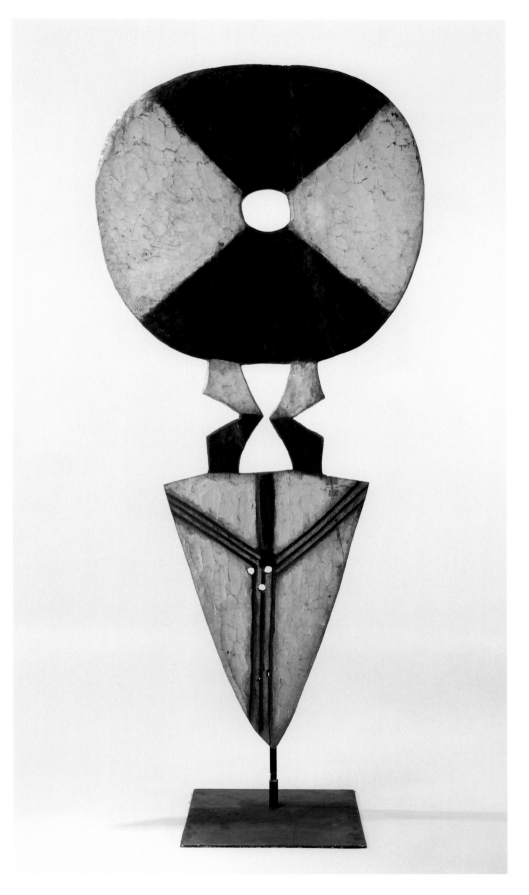

PLATE 16. *Bedu Mask.* Côte d'Ivoire and Ghana; Nafana, Kulango, or Degha, 20th century. Polychromed wood. 108 x 50 x 4 in. (274.3 x 127 x 10.2 cm).

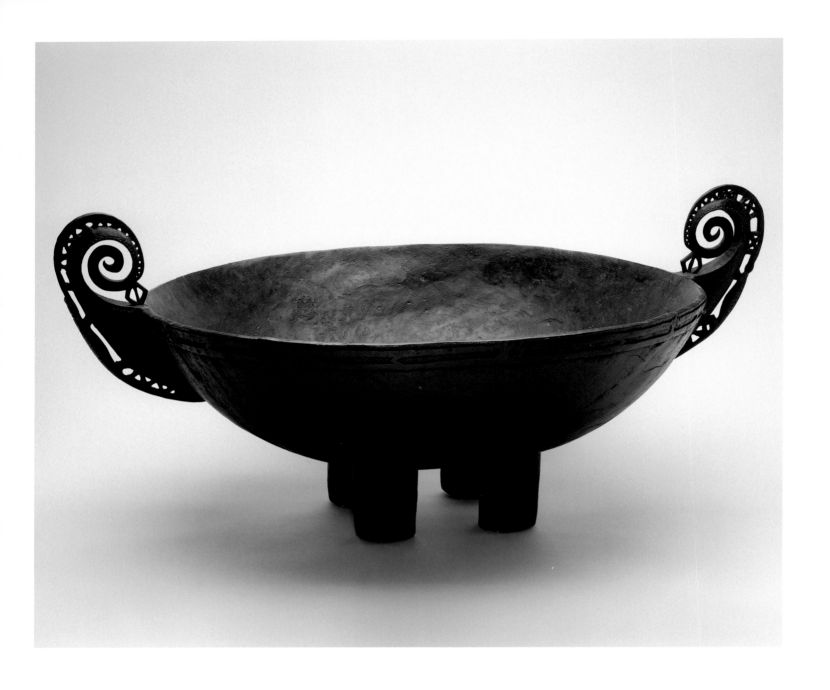

PLATE 17. *Ceremonial Feast Bowl.* Matankor, ca. 19th century.
Wood and plant fiber. 25¾ x 52⅞ in. (65.4 x 134.3 cm).

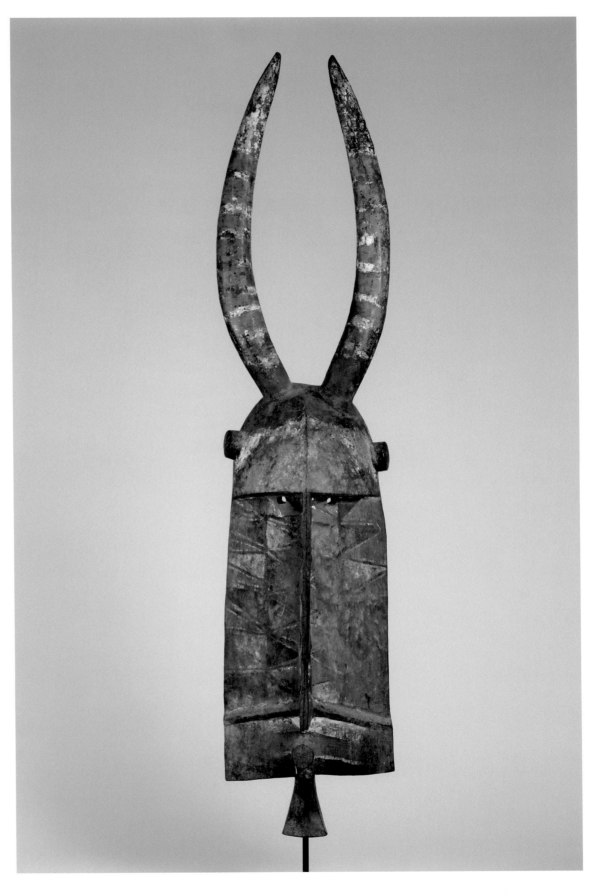

PLATE 18. *Molo Mask.* Burkina Faso; Bobo, 20th century.
Polychromed wood. 65½ x 14 x 13½ in. (166.4 x 35.6 x 34.3 cm).

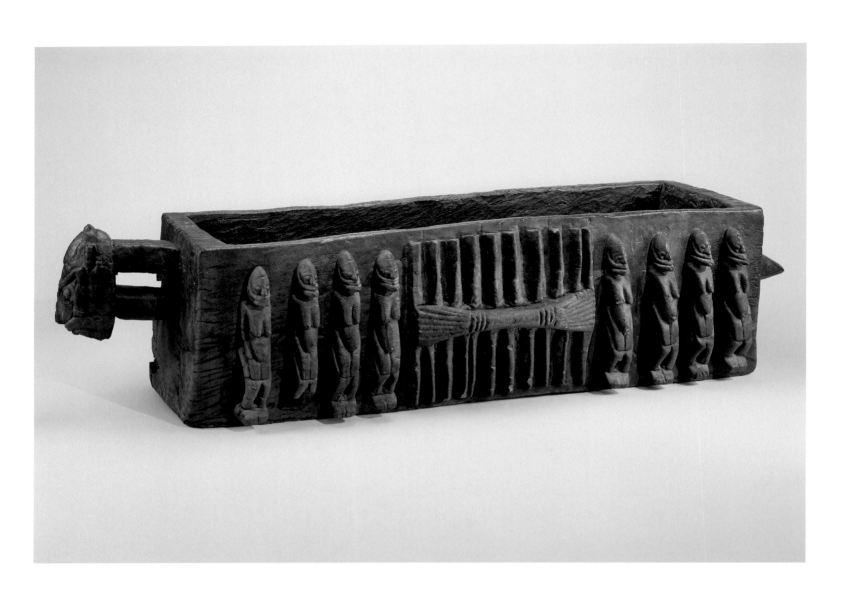

PLATE 19. *Ceremonial Trough with Horse's Head and Tail.* Dogon, 18th or early 19th century. Wood. 18 x 76¾ x 19½ in. (45.7 x 195 x 49.5 cm).

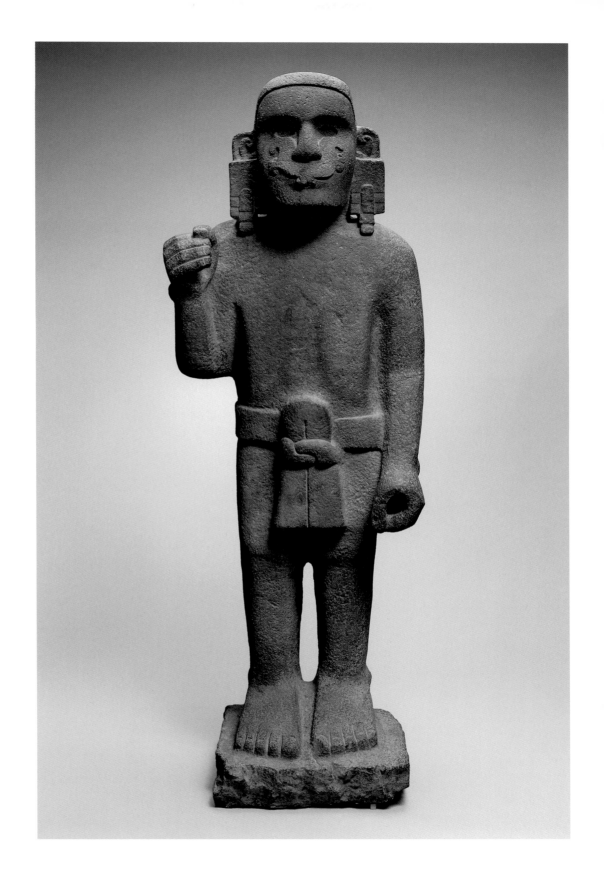

PLATE 21. *Anthropomorphic Monolith (Akwanshi).* Cross River region, Nigeria; ca. 16th–19th century.
Stone. 41 x 15 x 8 in. (104.1 x 38.1 x 20.3 cm).

SHARING A VISION

The de Menils and the Modern

ANN TEMKIN

FIGURE 18. Dominique de Menil with Alfred H. Barr Jr., founding director of The Museum of Modern Art, New York, at the opening of "Six Painters" at the University of St. Thomas, Houston, 1967.

OPPOSITE: René Magritte (1898–1967). *La clef de verre (The Glass Key)*, 1959 (detail). See plate 25, p. 79.

"THINGS IN WHICH WE BELIEVE" is how John de Menil described, with characteristic simplicity and acuity, the works of art for which he and his wife, Dominique, provided their support.[1] De Menil did not say, but well could have, that their philanthropy also derived from "people in whom we believe." The relationship between the de Menils and The Museum of Modern Art, New York (MOMA), is one that pivots on the mutual admiration and respect between them and Alfred H. Barr Jr. (1902–1981), the museum's founding director (figure 18). Admittedly, Barr's museological vision was much more didactic than the de Menils' intuitive approach. He trained his art-historical eye specifically on the art of his time, while the de Menils let their curiosity roam over centuries and continents. But he and they shared a profound conviction that art has a place in the moral life of humankind.[2]

For the de Menils, New York was part of a geographical triangle that since 1941 outlined their life and work, its two other points being Houston and Paris. Although Houston remained the center of their business and civic activities, New York was their key source of art in the United States. Early on the de Menils lived in an apartment at 40 East 68th Street, and in 1951 moved to a townhouse at 111 East 73rd Street. Like their home in Houston, it was far from a typical showplace for wealth but was instead a unique environment with a palpable

magic. The character of the townhouse is evident in a pastel sketch sent by the artist Roberto Matta as a New Year's greeting in 1967 (figure 19), an elevation drawing that deftly reveals the treasures in the various rooms on the several floors of the residence. Matta's whimsical renderings are precise enough to allow the identification of paintings by Georges Braque, Max Ernst, René Magritte, Piet Mondrian, and others, as well as several African and Oceanic sculptures.[3] The townhouse served as a base for New York friendships with artists, dealers, scholars, and curators not only in the field of modern art, but in ancient and non-Western art as well. Entertaining was sometimes official — such as a luminous dinner for Ernst on the occasion of his 1961 retrospective at MOMA — but more often spontaneous and informal.

John de Menil provided nearly twenty years of service to the museum, as a trustee from 1962 to 1973 (the year he died) and most especially as a key member of an organization known as the International Council of The Museum of Modern Art from 1954 to 1973. The council supported the functions of the International Circulating Exhibitions Program, established in 1952 with a five-year grant from the Rockefeller Brothers Fund. The International Program sent scores of exhibitions of all kinds around the world and also oversaw the American Pavilion of the Venice Biennale. Soon after the program was established, museum officials realized that it needed a strong base of influential collectors for financial and diplomatic support. John de Menil was probably recruited by his friend Philip Johnson, architect of the de Menils' new house in Houston and the head of the museum's Department of Architecture and Design.[4] De Menil's devotion to the International Council was deep: he became vice president in 1957, and then served as vice chairman from 1965 until his death. The council's mission of cultural exchange was one embodied in his own life, as a Frenchman in the U.S. who remained very European and yet greatly appreciated things American.

The marvelous way in which John de Menil put his mind to work for the International Council is evident in a long report prepared in 1954.[5] He asserted that the council's mission had to extend beyond exporting the work of American artists, as that fell "far short of giving a complete picture of the culture of this country." His radical idea for a solution, coyly described as "delegating authority," was to tap leading cultural figures to organize shows that gave a broader view of American civilization. He drew up a list of brilliant suggestions, among which were:

FIGURE 19. Roberto Matta (1911–2002). *Untitled* [Interior view of the de Menils' townhouse in New York City], 1967. Pastel on paper. 19¾ x 25¾ in. (50.2 x 65.4 cm). The Menil Collection, Houston, gift of the artist.

a) Max Ernst organizing an American Indian show.

The wealth of archeological material in this country is immense. And here is a man who painted Arizona in 1926 before he ever saw it, who now is American, and who lives in close contact with the Indians. What a show he could do in cooperation with Breton, Malraux and René d'Harnoncourt.

b) Romanticism in America

In answer to those who say we are interested only in money [followed by an annotated list encompassing figures as diverse as Sarah Bernhardt, Emily Dickinson, and Frank Lloyd Wright].

c) America, The Land of Marcel Duchamp By Marcel Duchamp.[6]

We will never know what de Menil had in mind regarding the intriguing title and minimal description of the third suggestion. Apparently, he was aware of Duchamp's occasional and spectacular service as an exhibition organizer, whether for André Breton, Sidney Janis, or others. Thus, as early as 1954, de Menil was thinking along lines that led him in 1968 to propose and title the historic "Raid the Icebox I with Andy Warhol" at the Rhode Island School of Design Museum, Providence, in which Warhol arranged over four hundred objects he had selected from the institution's holdings.[7]

The de Menils' dedication to MOMA will always be tangible in the context of its collection. Between 1949 and 1969, they donated seventeen works of art to the museum. The couple were faithful supporters on whom Barr could depend when the appropriate opportunity arose, and the correspondence between them makes plain the way in which the partnership worked. The de Menils nurtured special passions within modern art and wished to provide them with a presence at MOMA. In 1960, gracefully demurring from Barr's suggestion of a certain way to apply leftover funds from a prior gift, John de Menil explained that "we prefer to give the Museum things which we like ourselves and which we would be glad to own."[8] In 1963 he expressed reservations about the suggested gift of a Takis sculpture with which he was unfamiliar: "That creates an embarrassing situation: a little bit like going to bed with a girl without having seen her."[9] The charm of the analogy is now outdated, but it nonetheless conveys the highly personal terms in which the de Menils viewed their donations.

This point was reinforced when in 1964 curator Dorothy Miller wrote the de Menils to ask what credit line they preferred for publication of their

gifts in an upcoming catalogue of the painting and sculpture collection. John de Menil wrote back to veto the suggested wording of "Dominique and John de Menil Fund": "[It] never was, and still is not at present, our intention to create a purchase fund at the Museum of Modern Art. As you know, our first responsibility is in Houston and that is where our efforts must be concentrated . . . because here we are almost alone. So when we contribute something to the collection of the Museum, it is for a specific work with which Alfred Barr or you has fallen in love, as well as we have."[10]

Correspondence suggests that the de Menils' habit of making gifts to the museum was initiated by Alexander Iolas, director of the Hugo Gallery at 26 East 55th Street, New York. Iolas, a Greek expatriate, had directed the couple to Surrealism, and before long they became his best clients. Early on he recognized that he could leverage their dedication to benefit both MOMA and his stable of artists. In June 1949, Iolas informed Barr that a donor would be willing to give MOMA paintings by Victor Brauner, Stanislas Lepri, and Magritte. Barr assumed the donation was to be anonymous, but soon thereafter Dominique de Menil wrote him to confirm the offer.[11] The tempera painting by the now-forgotten Lepri, *Banquet*, 1945, was then on view at MOMA in the exhibition "Twentieth Century Italian Art"; exceptionally among the de Menils' donations to the museum, this work did not represent an artist of particular interest to them. In

contrast, they adored the paintings of Brauner, an important Surrealist whose oeuvre remains too little known in the U.S. The encaustic painting *Pentacular Progression*, 1948, was the first work by the artist to enter the museum's collection.

Barr had reservations about the three examples by Magritte that Iolas asked him to consider, but wondered whether "the donor would permit us to look through the shipment of Magrittes which I believe you expect during the course of the next few months. We would like to see a good recent work by Magritte in the Museum Collection."[12] The director's relative lack of excitement about Magritte seems puzzling today, given the artist's enormous popularity and indisputably grand stature. But in fact, as late as 1949, the Belgian Surrealist was little appreciated in New York. His first American exhibition, held at the Julien Levy Gallery in Manhattan in 1936, brought no sales apart from five paintings the dealer took for himself. That same year, Barr did include ten of his works in the landmark exhibition "Fantastic Art, Dada, Surrealism." But more than a decade later, the one painting Barr purchased from the show, *Le faux miroir* (*The False Mirror*), 1928 (figure 20), remained the only example by Magritte in the museum's collection.

By 1947 Iolas had taken on Magritte's cause as his own. He replaced Levy as the artist's agent in the U.S., and gave him solo shows in New York in 1947 and 1948, followed by seven more in the city over the course of the artist's life. It would not

be until the end of 1950, a year and a half after Iolas made the offer on the part of the de Menils, that Barr and his colleagues finally found among the Magrittes to arrive at the Hugo Gallery "a picture which we all agree is of extraordinary quality." The painting was a new work, *L'empire des lumières II* (*The Empire of Light II*), 1950 (plate 22, p. 76).[13] "Not only is the canvas beautifully painted, but the paradoxical poetry is much more subtle than is usual in Magritte," Barr wrote, even then extending only a backhanded compliment.[14] Evidently unperturbed, on January 3, 1951, John de Menil sent MOMA a check for $1,200 to pay for the painting. Perhaps he was impressed by Barr's determination to wait until the right work came along. Indeed, a year later, the de Menils requested from Iolas an *Empire des lumières* for themselves.[15] Ultimately, their collection would include fifty-four examples by Magritte, second in number only to those by Max Ernst.

The Empire of Light II is the second of what would be twenty-one paintings and gouaches depicting this motif, which over time became Magritte's best-selling image.[16] All share the distinctive feature of a dark street, lined by building fronts and trees, below a bright blue sky with fluffy white clouds. As is true for all of Magritte's paintings, the impossibility of the scene could well escape a viewer, so utterly plausible and concrete is its representation. Here, Magritte transposed the outlandishness of the nineteenth-century French poet Comte de Lautréamont's "umbrella and sewing machine meeting on an dissecting table" into deceptively ordinary terms.[17] The clouds have a lifelike presence as they float through the air; each tiny dark leaf is precisely outlined against the intensely hued sky; the opaque area in the center deftly captures the pitch-black of night. The top section defines the quintessential balmy beauty of "sky blue"; in the lower section, the only source of light is a solitary street lamp, along with seven windows glowing orange-gold behind drawn curtains. In MOMA's version of the scene, the horizontal band formed by the cobblestone street in the foreground heightens the sense of the facades as a perfectly flat stage set. The drama Magritte presented is what he termed "visible poetry." "Finally," he stated, "my conception of the art of painting does not consist of a way of painting, but in what there is to be painted — that is to say, the description of an inspired thought."[18]

Over the next few years, with Iolas's energetic advocacy, Magritte's reputation in New York steadily increased. The artist would send the dealer photographs of works in progress or of those sold in Europe, and Iolas would respond by requesting multiple versions of the images he liked most. In May 1957, James Thrall Soby, then chairman of MOMA's Committee on Museum Collections, saw *Souvenir de voyage* (*Memory of a Voyage*), 1955 (plate 27, p. 81), at the Iolas Gallery.[19] A painting monumental both in actual size and psychological impact,

FIGURE 20. René Magritte (1898–1967). *Le faux miroir* (*The False Mirror*), 1928. Oil on canvas. 21¼ x 31⅞ in. (54 x 80.9 cm). The Museum of Modern Art, New York (133.1936).

Memory of a Voyage looks back to a series of nineteen "petrified" paintings (in these images, everything is rendered as if made of stone) that Magritte produced in 1950 and 1951. Excited about the picture, Soby was afraid that "the de Menils or somebody else may snap it up" before Barr had time to look at it.[20] But evidently, no such misfortune occurred, and two years later (museum processes being what they are), MOMA acquired the painting with funds provided by the de Menils.

Several of Magritte's "petrified" paintings depict a tabletop still life, suggesting that he was literalizing the French term for still life, "nature morte" (dead nature). *Memory of a Voyage* is among the few executed entirely in grisaille, the palette limited to a putty gray, with flecks of various blacks and grays to evoke the surface of stone.[21] The work portrays a man, hat and book in hand, standing in a small room beside a peacefully crouching lion. The only furniture is an oval table holding a candlestick and dish with four apples. Above the table hangs a picture that is appropriately painted as stone: it depicts a ruined tower in front of towering cliffs. Magritte further engaged in his usual play between "actual" and "painted" reality: the corners and ceiling molding of the room echo the frame of the painting within the painting, and the inscription "Magritte" on that painting serves as the signature

for the actual one. As is often true in his work, Magritte's inspiration sprang from a contrarian logic. By rendering all of the figures and objects — the man's skin and hair, the lion's fur, the wooden planks, the linen tablecloth, the gaseous flame, the silver candlestick — as made of stone, he ignored their true textures. But it is precisely because they are identically painted that, as viewers, we become all the more acutely sensitive to the qualities of what we know to be their individual properties.

The Belgian poet Marcel Lecomte, a close friend of Magritte's, posed for the standing man in *Memory of a Voyage*. But Magritte hastened to correct a MOMA description of the painting as a "portrait" of Lecomte: "The person who figures in this pictures ceases — as far as possible — to have an explicable meaning and — it is legitimate not to think that Marcel Lecomte served as the model in the sense in which a person is said to pose for his portrait."[22] Magritte's "petrified" rendering of Lecomte has as its ancestor Man Ray's *Portrait imaginaire de D. A. F. de Sade* (*Imaginary Portrait of D. A. F. de Sade*), 1938 (plate 26, p. 80), a work that Dominique de Menil would acquire in 1985. Lecomte was known to be an admirer of the Marquis de Sade, so Magritte's allusion to the earlier portrait may well have been intentional. But the joke revolving around Man Ray/Magritte/Sade/Lecomte

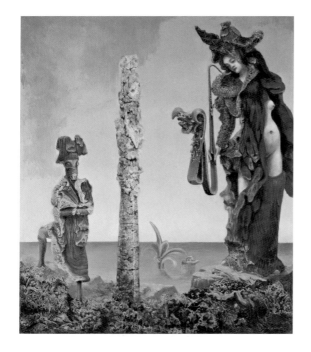

FIGURE 21. Max Ernst (1891–1976). *Napoleon in the Wilderness*, 1941. Oil on canvas. 18¼ x 15 in. (46.4 x 38.1 cm). The Museum of Modern Art, New York (12.1942).

was available only to the close circle of friends with whom Magritte kept company in Brussels. Beyond that, as Magritte insisted to the MOMA curators, the figure was to be an anonymous player in the artist's own game.

While the de Menils' enthusiasm for Magritte was greater than Barr's would ever be, on the subject of Max Ernst they saw eye to eye. Ernst was the de Menils' favorite artist and devoted friend; over the years, the couple amassed over one hundred examples by him. He was the first artist from whom the couple commissioned a work, a portrait of Dominique in 1934 (figure 22), when they visited him in Paris at the suggestion of the French architect Pierre Barbe. Barr too had been an early admirer, including no fewer than forty-eight works by the German artist in "Fantastic Art, Dada, Surrealism." In the mid-1930s, Barr acquired fourteen Ernsts for the museum, adding in 1942 *Napoleon in the Wilderness* (figure 21), which Ernst painted in New York the previous year. Despite this abundance, the de Menils still found the right gift to propose. In 1955 they offered to the museum Ernst's bronze sculpture *The King Playing with the Queen* (plate 2, p. 13), cast in 1954 from a plaster made ten years earlier. The de Menils, who had financed the bronze casting, kept two of the other casts: one for their residence in Houston and one

for their townhouse in New York. They enthused, "We think it is a wonderful piece to live with." And they continued, "We feel very close to the Museum of Modern Art, and we like to give you the kind of things in which we believe. We believe in Max Ernst."[23]

Another German artist whose work the de Menils avidly collected was Wols, born in Berlin in 1913 as Alfred Otto Wolfgang Schulze. While he is still little known in the U.S., he was and is admired in Europe as a key artist of the postwar years. His art was revered as the visual exponent of postwar existentialism, with its evocations of chaos that can be viewed as either cosmological or psychological. Today, his paintings read equally well as a quite literal description of Europe after 1945, with matter unraveling, decomposing, exploding, or simply fading out. Wols's personal story certainly qualified him as an existential hero: having left Germany for France, he was interned as a foreigner during the war, after which he lived and worked in a string of Left Bank hotels, penniless and alcoholic, until his death at the age of thirty-eight in 1951.

John and Dominique de Menil's gift of an untitled painting by Wols, 1946–47 (plate 29, p. 84), seems another instance of following up on a suggestion of Iolas's. The dealer had given Wols his

FIGURE 22. Max Ernst (1891–1976). *Portrait of Dominique*, 1934. Oil and graphite on canvas. 25¾ x 21¼ in. (65.4 x 54 cm). The Menil Collection, Houston.

first solo show in New York in 1950, and continued to represent the artist's work after his death. When John de Menil sent Barr a check to cover the purchase of the painting at the end of 1954, Barr replied with endearing candor, "I don't remember the painting," and assured his patron that he would go to the Iolas Gallery and take a look at it right away.[24] The canvas features an intensely complicated surface full of incident: impasto, splatters, scrawlings, incisions, and drips. All this occurs within extremely thin paint layers, more akin to watercolor than to oil. A crayonlike orange line defines a pale, squarish central shape set apart from the surrounding brown-gray atmosphere. That form prompted the artist's widow, Grety Wols, to call the painting "Veronica's Veil," a title Barr ultimately rejected.

John de Menil's ongoing interest in the gifts he had made is evident in a long and delightful correspondence with Barr concerning Wols's painting. When the museum displayed the work after finally acquiring it in 1956, Barr hung it in a manner that de Menil considered upside down. Apparently, he mentioned this to Barr from time to time, and in 1961 finally telephoned to complain.[25] Barr hastened to inform de Menil that he had not ignored his advice; he just was not persuaded of the case. As he explained, "If it is turned the other way, the two points with smudgy halos around

them seem to turn into tiny and somewhat absurd eyes."[26] One year later, de Menil let Barr know that he was still investigating the matter, now having initiated a trans-Atlantic correspondence with Werner Haftmann, the reigning authority on Wols.[27] Ultimately, after a prolonged search for installation photographs and consultation with Wols's widow, Haftmann agreed with de Menil.[28] The decision in part came from those "tiny and somewhat absurd eyes" that so bothered Barr. Grety Wols's title for the painting, "Veronica's Veil," while specific in a way that utterly contradicts the open spirit of Wols's work, nonetheless convinced the scholar that she had seen it in the studio "eye" side up. Barr reluctantly acceded to the expert's pronouncement and to his donor's persistence.[29]

The de Menils continued to make a variety of other gifts throughout the late 1950s and 1960s. The visionary character of their own collecting is perhaps most dramatically seen in their donations of a photomontage and a sculptural scale model by Christo, both presenting the artist's 1968 proposal for wrapping MOMA. The de Menils were by this time active champions of Christo, who was then in his early thirties. Having met the artist in New York in 1965, they owned several objects by him, including the *Corridor Store Front Project* (scale model), now in The Menil Collection. John de Menil worked valiantly for Christo in 1967,

FIGURE 23. Christo (b. 1935). *4584 Tonneaux Métalliques, Project for the Galleria Nazionale d'Arte Moderna, Rome*, 1967. Graphite, wax crayon, enamel paint, and collage element on cardboard, on paper. 21⅞ x 27⅞ in. (55.6 x 71 cm). The Menil Collection, Houston.

when the artist was hoping (in vain, as it turned out) to build near Houston a giant mastaba of five hundred thousand oil barrels as part of an ongoing series of similar projects proposed for such places as the Galleria Nazionale d'Arte Moderna in Rome (figure 23).[30] The MOMA project would have featured the wrapping of the museum and the draping of the sculpture garden, and, for one evening, a mastaba of 441 oil barrels constructed across 53rd Street. The event would have constituted Christo's first museum wrapping and a milestone in New York cultural history. De Menil and several other MOMA trustees used all the muscle they could to clear the way for the ambitious undertaking. Ultimately, it was not enough, and the project got no further than preparatory studies.

Christo had proposed the wrapping to William Rubin, director of MOMA's Department of Painting & Sculpture, early in 1968. Rubin enthusiastically welcomed it as an adjunct event for the exhibition "Dada, Surrealism, and Their Heritage," which featured Christo's work in the "heritage" section. He perceived an affinity between Christo's approach and the Surrealist penchant for hiding and disguise that is evident in such works as Man Ray's The Enigma of Isadore Ducasse, 1920 (reconstructed 1970). After the wrapping and mastaba projects were deemed infeasible, Rubin gamely responded with a lobby exhibition entitled "Christo Wraps the Museum: Scale Models, Photomontages, and Drawings for a Non-event." He wrote in the exhibition brochure:

> As an artist functioning more in the realm of "events" than in that of painting and sculpture, it is not surprising that [Christo] should have dreamed that it was time to wrap up the Museum — and for that matter the trees, the sculptures, and even some of the spectators in its garden. The Museum staff found this a potentially lively and poetically strange project. But the more practical heads of the fire department, police department, and insurance agencies prevailed.[31]

A framed 1968 work explains the project through a pencil drawing on tracing paper placed beneath a large photomontage (plate 32, p. 87). In this quick architectural sketch, Christo used a red pencil to indicate what the wrapping would cover. For the photomontage, he asked the photographer Ferdinand Boesch to document the actual site and model. His photos were then scaled, juxtaposed, and cut and pasted in such a way that the result serves as a deceptively convincing record of an actual event. Complete with passing cars, adjacent buildings, and a meticulously silhouetted street lamp, the 53rd Street scene seamlessly accommodates

the oversized and strangely charismatic package in its midst.

The 1968 scale model (plate 31, p. 86) is an immaculate construction portraying the wrapping that covers the museum building in its entirety, as well as the wall behind the garden along 54th Street. In reality the project would have involved a seventy-thousand-square-foot canvas tarpaulin, bound with thousands of feet of nylon rope. Here, thin cotton has been bunched, folded, gathered, and held in place with heavy white twine and cream-colored thread. The beauty of the model lies in the network of intersecting lines — vertical, horizontal, and diagonals of all sorts. Traversing the walls and roof, negotiating corners and edges, they have the vitality of the skeins of paint that cover a Jackson Pollock "drip" canvas. It is at once apparent that Christo's wrappings are sculptural tours de force, as well as events requiring planning of military scale. But the model is as charming as it is powerful, complete with little cardboard people and a hand-lettered version of MOMA's vertical sign along 53rd Street.[32]

The logistical obstacles to the project had much to do with the turbulent climate of the moment. On the heels of the turmoil engendered by the assassination of Martin Luther King Jr., student riots in Paris, and student demonstrations at Columbia University, Christo's concept struck city officials as a potential provocation for unrest. Yet it was precisely the artist's engagement with reality, his preference for the actual world over the cloistered gallery, that attracted the de Menils to his work. Their support of Christo's unrealized project was a great tribute to the adventurous spirit that characterizes MOMA at its best.

That spirit was one that the de Menils would always associate with Alfred Barr, who had retired the year before the Christo project was proposed. At that time, John de Menil wrote Barr a short but eloquent tribute:

Dear Alfred,

If ever there was a man who could retire with peace and pride, it is you. The museum you have created is capital. It has a life of its own. It will grow. From your retreat you will watch it with love like a father who sees his son develop his own career: a combination of amazement and pride. And you will keep contributing to it by your writings which I await with great expectation.

Yours devotedly,
John de Menil[33]

NOTES

1. John de Menil to Alfred H. Barr Jr., Dec. 9, 1955, Museum Collection Files, Department of Painting & Sculpture, The Museum of Modern Art, New York (hereinafter Painting & Sculpture Collection Files, MOMA).

2. Barr had an ongoing interest in the question of modern art and religion. He was an admirer of the de Menils' great friend and inspiration Father Marie-Alain Couturier, a French Dominican priest who had devoted himself to the establishment of a link between the modern church and modern artists.

3. The works that can be identified include Braque's *Grand intérieur à la palette* (*Large Interior with Palette*), 1942; Ernst's *Deux points cardinaux* (*Two Cardinal Points*), 1950; Magritte's *Force des choses* (*Force of Circumstance*), 1958; Mondrian's *Composition with Yellow, Red and Blue*, 1927; Picasso's *Sketch of André Salmon*, 1907; and *War and Hunting God (Yipwon)*, a wood sculpture from Papua New Guinea. All are now in The Menil Collection, Houston.

4. Minutes from the Oct. 21, 1953, meeting of the International Council, n.p., Minutes of the International Council of The Museum of Modern Art, New York (hereinafter MOMA International Council Archives).

5. "Notes Prepared by Mr. John de Menil Extending His Remarks Made at the Meeting of the International Council on May 4, 1954," n.p., MOMA International Council Archives.

6. Ibid.

7. *Raid the Icebox I with Andy Warhol*, exh. cat. (Providence: Rhode Island School of Design, 1969). The exhibition opened in Houston in 1969 and traveled to New Orleans before its showing in Providence in 1970.

8. John de Menil to Barr, July 15, 1960, Donor Files, Department of Painting & Sculpture, The Museum of Modern Art, New York (hereinafter Painting & Sculpture Donor Files, MOMA).

9. John de Menil to Barr, July 9, 1963, Menil Archives, The Menil Collection, Houston.

10. John de Menil to Dorothy Miller, Jan. 15, 1964, Painting & Sculpture Donor Files, MOMA.

11. Dominique de Menil to Barr, June 29, 1949, Painting & Sculpture Collection Files, MOMA.

12. Barr to Alexander Iolas, June 21, 1949, Painting & Sculpture Collection Files, MOMA.

13. MOMA calls this painting *The Empire of Light*, while The Menil Collection calls its version *The Dominion of Light*, which follows the translation from the French in Sarah Whitfield and Michael Raeburn, *René Magritte, Catalogue Raisonné*, vol. 3 (Houston: The Menil Foundation; London: Philip Wilson, 1993), no. 814.

14. Barr to the de Menils, Dec. 26, 1950, Painting & Sculpture Collection Files, MOMA.

15. *L'empire des lumières*, 1952, was formerly in the collection of Georges de Menil; see Whitfield and Raeburn (note 13), no. 781.

16. Nelson Rockefeller bought the first version; see ibid., no. 709.

17. Comte de Lautréamont, *Les chants de Maldoror* (1869), as quoted in Marcel Jean, *The Autobiography of Surrealism* (New York: Viking, 1980), p. 52.

18. René Magritte to James Thrall Soby, June 4, 1965; cited here is Monroe Wheeler's translation from the French, dated June 10, 1965. Both are in Painting & Sculpture Collection Files, MOMA.

19. Iolas had by then taken over and renamed the Hugo Gallery. This painting was shown in the Magritte exhibition at the Galerie Cahiers d'Art, Paris (Dec. 1955–Jan. 1956), from which Iolas bought it.

20. Memo from Betsy Jones to Barr, May 17, 1957, Painting & Sculpture Collection Files, MOMA.

21. Magritte gave the name *Souvenir de voyage* to many works made between 1926 and 1962; see Whitfield and Raeburn (note 13), as well as David Sylvester and Sarah Whitfield, *René Magritte, Catalogue Raisonné*, vols. 1–2 (Houston: The Menil Foundation; London: Philip Wilson, 1992–93).

22. Magritte, in questionnaire completed Sept. 17, 1965, Painting & Sculpture Collection Files, MOMA. Translation from the French follows that in Whitfield and Raeburn (note 13), no. 827.

23. John de Menil to Barr, Dec. 9, 1955, Painting & Sculpture Collection Files, MOMA.

24. Barr to John de Menil, Jan. 6, 1955, Painting & Sculpture Collection Files, MOMA.

25. Memo from "Frances" to Monroe Wheeler, Dec. 5, 1961, Painting & Sculpture Collection Files, MOMA.

26. Barr to John de Menil, Dec. 19, 1961, Painting & Sculpture Collection Files, MOMA.

27. John de Menil to Barr, Dec. 29, 1962, Painting & Sculpture Collection Files, MOMA.

28. Werner Haftmann to John de Menil, Dec. 12, 1962, Painting & Sculpture Collection Files, MOMA.

29. Barr to John de Menil, Jan. 21, 1963, Painting & Sculpture Collection Files, MOMA.

30. Telephone conversation between Jeanne-Claude and Christo and author, Dec. 12, 2006.

31. William Rubin, *Christo Wraps the Museum: Scale Models, Photomontages, and Drawings for a Non-event*, exh. brochure (New York: Museum of Modern Art, 1968).

32. Other gifts to the museum related to this unrealized project are *441 Barrels Structure — "The Wall" (Project for 53rd between 5th and 6th Avenues)*, a drawing donated by Louise Ferrari, a private dealer in Houston and close friend of the de Menils; and *Packed Tree (Project)*, a cardboard model donated by the artist.

33. John de Menil to Barr, May 22, 1967, Painting & Sculpture Donor Files, MOMA.

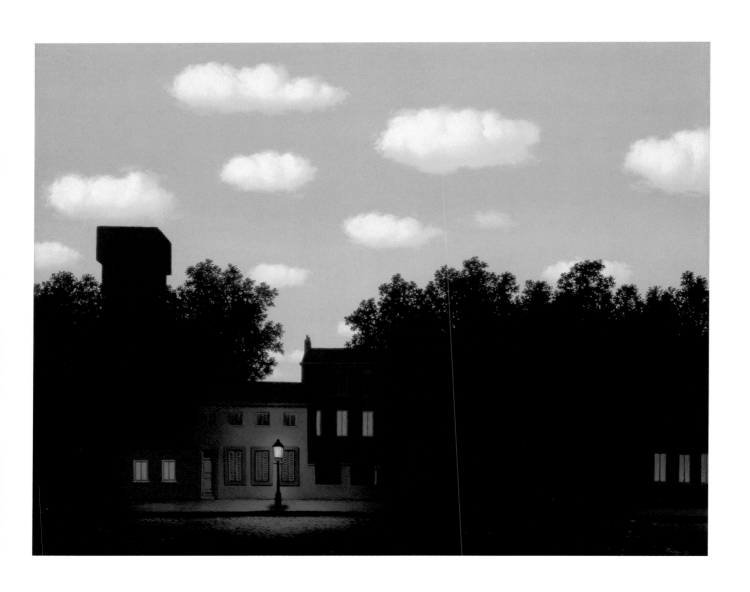

PLATE 22. René Magritte (1898–1967). *L'empire des lumières II (The Empire of Light II)*, 1950.
Oil on canvas. 31 x 39 in. (78.7 x 99.1 cm).

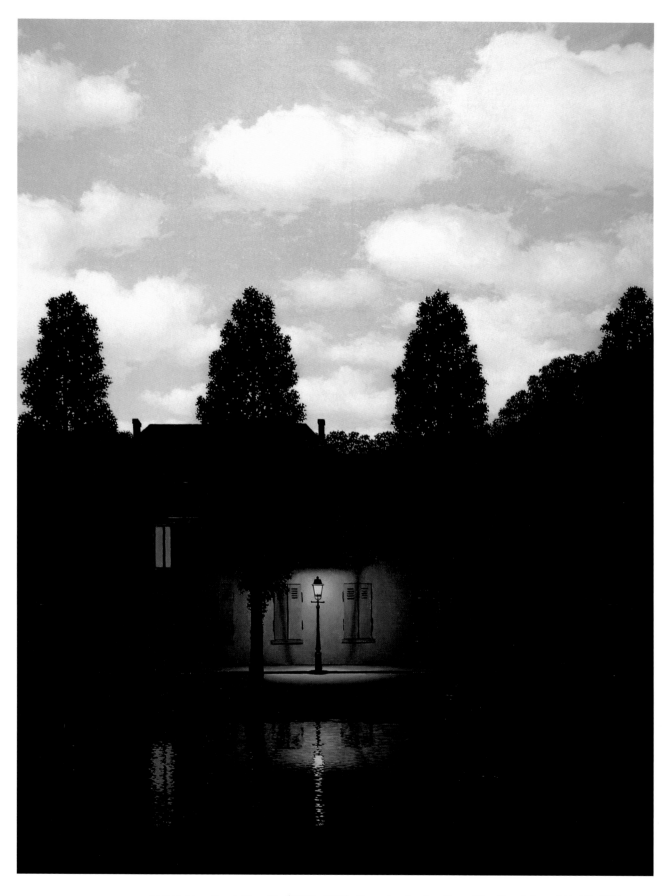

PLATE 23. René Magritte (1898–1967). *L'empire des lumières (The Dominion of Light)*, 1954.
Oil on canvas. 63¾ x 51⅛ in. (161.9 x 129.9 cm).

THE MENIL COLLECTION, HOUSTON 77

PLATE 24. René Magritte (1898–1967). *Le monde invisible (The Invisible World)*, 1954. Oil on canvas. 77 x 51⅝ in. (195.6 x 131.1 cm).

PLATE 25. René Magritte (1898–1967). *La clef de verre (The Glass Key)*, 1959.
Oil on canvas. 51⅛ x 63¾ in. (129.9 x 161.9 cm).

THE MENIL COLLECTION, HOUSTON 79

PLATE 26. Man Ray (1890–1976). *Portrait imaginaire de D. A. F. de Sade (Imaginary Portrait of D. A. F. de Sade)*, 1938.
Oil on canvas with painted wood panel. 24¼ x 18⅜ in. (61.7 x 46.6 cm).

PLATE 27. René Magritte (1898–1967). *Souvenir de voyage* (*Memory of a Voyage*), 1955. Oil on canvas. 63⅞ x 51¼ in. (162.2 x 130.2 cm).

THE MUSEUM OF MODERN ART, NEW YORK, GIFT OF D. AND J. DE MENIL, 1959 81

PLATE 28. Wols (Alfred Otto Wolfgang Schulze) (1913–1951). *Manhattan*, 1948–49.
Oil on canvas. 57½ x 38⅜ in. (146.1 x 97.5 cm).

PLATE 29. Wols (Alfred Otto Wolfgang Schulze) (1913–1951). *Painting*, 1946–47.
Oil on canvas. 31⅞ x 32 in. (81 x 81.3 cm).

PLATE 30. Wols (Alfred Otto Wolfgang Schulze) (1913–1951). *Untitled* (*It's All Over* or *The City*), 1946–47.
Oil on canvas. 31⅞ x 31⅞ in. (81 x 81 cm).
THE MENIL COLLECTION, HOUSTON 85

PLATE 31. Christo (b. 1935). *The Museum of Modern Art Packaged*, 1968.
Scale model: painted wood, fabric, twine, and polyethylene. 16 x 48⅛ x 24⅛ in. (40.6 x 122.2 x 61.3 cm).

PLATE 32. Christo (b. 1935). *The Museum of Modern Art Packaged Project,* 1968.
Cut-and-pasted gelatin silver prints (by Ferdinand Boesch) with oil on board, pencil, colored pencil,
cut and pasted tracing paper, and pressure-sensitive tape on board. 21¾ x 15½ in. (55.2 x 39.4 cm).

PLATE 33. Christo (b. 1935). *Empaquetage of a Public Building, Project for the Galleria Nazionale d'Arte Moderna, Rome,* 1967. Photomontage and pencil on paper. 24 x 34 in. (61 x 86.4 cm).

PLATE 34. Christo (b. 1935). *Wrapped Museum, Project for the Galleria Nazionale d'Arte Moderna, Rome,* 1967–68. Fabric and twine on wood, mounted on painted wood base. 10 x 48 x 24 in. (25.4 x 121.9 x 61 cm).

DYNAMISM IS CONTAGIOUS

Dominique de Menil and the Birth of the Centre Pompidou

ALFRED PACQUEMENT

FIGURE 24. Max Ernst with Dominique and John de Menil at the opening of "Max Ernst: Inside the Sight" at Les Salles de l'Orangerie, Paris (April 25–May 31, 1971).

BORN IN FRANCE, Dominique de Menil (née Schlumberger) was always deeply attached to her native land. Even though during World War II she moved to Houston with her husband, Jean[1] — who was French as well — her ties with France continued to be strong. Exceptionally generous, open-minded, and actively engaged with the visual arts, the couple contributed liberally to the cultural life of their adopted city, establishing The Rothko Chapel and the Institute for the Arts at Rice University and supporting the Museum of Fine Arts, Houston. After Jean de Menil's death in 1973, Dominique continued their efforts, culminating in the opening of The Menil Collection in 1987. But part of the de Menils' hearts remained in France, to which they often traveled, staying at their home on the rue Las Cases, Paris, or at the Schlumberger family property in Val Richer.

While this essay focuses on the period after Jean de Menil's death, it is important here to provide an overview of the couple's involvement with French museums before 1973. The de Menils made their first gifts to French state collections in support of the acquisition of older artworks. Both the Musée des Beaux-Arts, Strasbourg, and the Musée du Louvre, Paris, had asked the de Menils to help them acquire objects being offered on the market. In 1970 the couple contributed funds to the Strasbourg museum to purchase a work by

OPPOSITE: Jackson Pollock (1912–1956). *The Deep*, 1953 (detail). See plate 35, p. 105.

the seventeenth-century Flemish artist Christian van Couwenberg (figure 25). The painting, which depicts three white males and a black female, was particularly meaningful to the couple, who were ardent about the struggle against racism and became deeply interested in the representation of blacks in Western art. "We are happy," Jean de Menil wrote to the director of French national museums, "to have been able to aid in the acquisition of an important painting which depicts us, whites, in a manner which we would prefer to ignore."[2] The following year, they offered to the Louvre one of two rare paleo-Christian mosaics: "We would be happy, Jean and I," wrote Dominique de Menil, "to give to the Louvre the more beautiful of the two mosaics, or at least the one of your choosing."[3] They kept for themselves the mosaic the museum did not select. That the de Menils offered the Louvre first choice, especially given that they were already planning a museum of their own, or at least preparing to open their collection to the public, demonstrates the extent of their generosity.

Passionate defenders of modern art, the de Menils had been upset by the lack of interest on the part of French museums in the most innovative artistic trends, and by these institutions' nationalism, which limited their understanding and presentation of contemporary culture. Some exceptions existed here and there, but on the whole, the nation's museums were dishearteningly traditional. Surrealist art, much loved by the de Menils, was scarcely represented: for example, the Musée National d'Art Moderne (MNAM) had no works by Giorgio di Chirico or René Magritte. Contemporary art was even more rare, especially American art; even a large show organized by The Museum of Modern Art, New York (MOMA) of work by Jackson Pollock and new American painting that traveled to the MNAM in 1959 had not affected the development of the museum's collection.

Ironically, it was a Frenchman, the Dominican priest Marie-Alain Couturier, an exile in New York during World War II, who played a crucial role in introducing the de Menils to modern art. Father Couturier strongly supported re-establishing the Catholic Church's centuries-long tradition of commissioning art and architecture from leading contemporary artists. He guided the de Menils through numerous New York galleries, encouraging them to make their first important acquisitions. When Father Couturier returned to France in 1945, he commissioned art for churches in Assy, Audincourt, Ronchamp, and Vence from artists such as Georges Braque, Marc Chagall, Fernand Léger, Henri Matisse, and Georges Rouault, but his efforts did not radically affect French museums'

FIGURE 25. Christian van Couwenberg (1604–1667). *La rapt de la négresse (The Rape of a Negress)*, 1632. Oil on canvas. 41 x 50 in. (104 x 127 cm). Musée des Beaux-Arts, Strasbourg; Purchase, with funds from the Menil Foundation and Robert Heitz, 1970 (Inv. no. 2367).

acquisition of works by this first generation of modern masters.

Eventually, things changed in France. A new generation took the reins of the nation's cultural institutions. In 1967 the Centre National d'Art Contemporain (CNAC) was created — with Blaise Gautier as director — to counterbalance the MNAM's lack of initiative. The CNAC increased the number of innovative exhibitions, while actively pushing to fill the most notable lacunae in the national collections. In 1971 it presented in Paris a tribute to Max Ernst, showing his work at Les Salles de l'Orangerie, home of Claude Monet's famous *Waterlilies* (figures 24, 26). Organized by the Institute for the Arts at Rice University, "Max Ernst: Inside the Sight" was noteworthy in that the works it included were drawn almost entirely from the de Menils' collection. The show traveled extensively in the U.S., Germany, and France. The organizers of the exhibition in Paris significantly augmented the presentation with over forty important works by Ernst from major French collections.[4] This expanded version was a double tribute: to one of the greatest artists living in France (in honor of his eightieth birthday), and also to two important French-born collectors then little known in the nation's artistic circles. It was highly unusual for one of France's most prestigious museums to show a private collection, but this exhibition was indeed an exceptional case: while it looked at the career of an artist through the lens of an extraordinary collection, it focused on the work, not on the identity of the owners.

Shortly thereafter, the CNAC staged an exhibit of the work of Louis Fernandez, a painter of still lifes and skulls much loved by the de Menils, who lent several works for the occasion. Jean de Menil encouraged the CNAC to find a venue outside France for the show in order to present the artist to a broader audience; indeed, it subsequently traveled to the Musée des Beaux-Arts, Charleroi, Belgium.[5] Not only did the de Menils help fund the exhibition, but they donated to the French national collections a portrait by Fernandez of Marie-Laure de Noailles (figure 27), in honor not only of a beloved artist, but also of a leading French patroness of modern art — especially Surrealism — who illuminated the way for art lovers in her own country. This was the first modern work the de Menils presented to their native land; they made the gift shortly before Jean de Menil died.

In 1969 Georges Pompidou, the newly elected president of the republic, announced plans for a large cultural center, to include a museum and a public library; after his death, it was named for him. When the Centre Pompidou was created,

FIGURE 26. Dominique de Menil, Max Ernst, and Alexander Iolas during the installation of "Max Ernst: Inside the Sight" at Les Salles de l'Orangerie, Paris (April 25–May 31, 1971).

Pontus Hulten (1924–2006) (figure 28) was selected as director of the MNAM—the heart of this new institution. Hulten, who was Swedish, had been director of Stockholm's Moderna Museet, where he had organized major exhibitions of modern and contemporary art. One of the innovations intended to help realize the Pompidou was the establishment, in 1974, of an autonomous acquisitions committee. Acting separately from the other national museums, which were not all that disposed to acquiring modern art, the committee could function well and act swiftly. Under the leadership of the new director, the collection was transformed in just a few years. In addition to its own funds, the MNAM received generous gifts, stimulated by this exciting new project and by the prospect of the relocation of the museum to a spectacular new building (figure 29).

Hulten respected Jean and Dominique de Menil, whom he had known for many years. They clearly had much in common. Among their shared interests was the work of the Swiss artist Jean Tinguely, which Hulten had exhibited in Sweden. In 1965, when the artist was still little known, Jean de Menil had had the foresight to acquire for the Museum of Fine Arts, Houston, an entire exhibition of Tinguely's work, which he saw at Alexander Iolas's gallery in Paris. Dominique de Menil recalled, "The space . . . looked terrific with all those absurd and sublime machines, and John thought they should remain together."[6] Not surprisingly, Hulten approached her, asking her to join the new acquisitions committee as one of only two private collectors (along with René de Montaigu; the other members were curators and administrators of cultural organizations). Her response was enthusiastic: "I feel very moved that my name appears among the seven members of the new committee. I don't know if I can be of much help, since I am so tied in Houston, for the time being, but I accept the invitation to join the committee with pleasure. It will give me an opportunity to learn more about what is going on in the art world today."[7]

It is important to keep in mind that the de Menils were not nationalistic in their approach to art. For them, great art had no boundaries, as their collection, which encompasses many civilizations, attests. The couple's interest in Yves Klein, Martial Raysse, and Tinguely, for example, shows their openness to European contemporary art at a moment when most American collectors tended to ignore it. Iolas (see figure 26), who for a long time was the dealer closest to the couple, promoted Surrealism but also the art of younger Europeans.

FIGURE 27. Louis Fernandez (1900–1973). *Portrait de Marie-Laure de Noailles*, 1945. Graphite and oil on canvas. 45¾ x 35¼ in. (116 x 89.5 cm). Musée National d'Art Moderne, Centre Pompidou, Paris; Gift of Jean and Dominique de Menil to the Nation, 1972.

Nonetheless, the de Menils had become great enthusiasts of certain American artists, especially Mark Rothko, who in 1966–67 created the paintings for the chapel that the de Menils built in Houston; Barnett Newman, whose *Broken Obelisk* was placed in a reflecting pool near the entrance to the chapel; Andy Warhol; and others.

Becoming involved with the birth of the highly anticipated Centre Pompidou meant, of course, filling the collection's most significant gaps. And, considered from a perspective west of the Atlantic, the MNAM was sorely lacking in American art. Where and how to begin? The elevated prices of American art exceeded the museum's resources; thus, the support of private patrons became indispensable. Dominique de Menil rose to the occasion through both financial assistance and gifts of works of art. Her partnership with the museum had actually begun before she joined the acquisitions committee, when she became involved with the donation of a major American work. Of all the talented American painters active in the mid-twentieth century, one stood out: Jackson Pollock. The collection included only a single Pollock, a classic "drip" painting of modest dimensions acquired a few years earlier. Despite its qualities, the work's small format could not illustrate this artist's achievements fully. A large Pollock, worthy of the new museum and its ambitions, had to be located. Sometime earlier, France had missed out on the artist's monumental *Blue Poles*, whose price had intimidated every European museum; it was bought by the distant National Gallery of Australia, Canberra. Now *The Deep*, 1953 (plate 35, p. 105), had become available. This critical painting from Pollock's last period belonged to the American curator/collector Samuel Wagstaff; Xavier Fourcade, an important New York dealer of French origin, negotiated the sale. Dominique de Menil was involved in discussions with Hulten regarding this purchase from the beginning. In February 1974, she wrote to him, "Wagstaff needs the money. This is a good point to know when you bargain." She added, "I think we're on the right track. They want to sell. The market is dead. No one has money."[8] Their correspondence coincides precisely with the creation of the acquisitions committee, and in April the Menil Foundation purchased the work for the Centre Pompidou.

In early April 1974, Georges Pompidou died, without having been able to inaugurate the building he had dreamed of. Dominique de Menil sent Hulten a long letter in French, a translation of which deserves to be quoted in its entirety:

Dear Pontus,

The death of Pompidou saddened me. I had hoped that he would live long enough to see finished the Centre Beaubourg [Pompidou]. He started it; one would have wished that he had seen the finish of it. His creative impulse continues to change the ancient map of Europe. Paris, which risked being a bit dragged down, has all the chances of again becoming the most stimulating place in Europe for artists.

I wanted to make an important donation to Beaubourg in memory of Jean. He would have rejoiced in your nomination and would have wanted to celebrate it by a grand gesture, as he knew to do when the circumstances dictated it to him. It's a case of three or four canvases of American painters who marked the 50s and 60s. One of them will be a painting of Pollock of 1953 — *The Deep* — of which the Menil Foundation possesses more than three-fourths. I wish to associate my children with this gift, and it is with them that I will resolve the definite choice of the other works.

I would like the donation to be announced only at the moment when we will be ready to issue our appeal to the French affairs [corporations] that are working in America, as well as to all friends of France.

I believe that an enterprise such as Beaubourg will stir up enthusiasm because it marks a new youth for France in the world of arts. Dynamism is contagious.

Fondly,
Dominique[9]

At her suggestion, *The Deep* was shown first at the Museum of Fine Arts, Houston, which allowed her community to benefit from its purchase. In 1976 it was lent to MOMA for an exhibition,[10] after which it was sent to Paris for the inauguration of the Centre Pompidou on January 31, 1977.

This masterpiece by Pollock had an immediate and profound effect on the collection of the MNAM. Instead of choosing a typical "all-over" or "drip" painting, Hulten and de Menil had opted for a unique work, one that is indispensable for any serious retrospective of the artist. In the last years of his life, Pollock questioned his earlier abstractions, re-introducing figures and the suggestion of pictorial depth. Comparing *The Deep* to Édouard Manet's *Olympia*, 1863 (Musée d'Orsay, Paris), the poet Frank O'Hara described Pollock's painting as "a work which contemporary esthetic conjecture had cried out for . . . one of the most provocative images of our time, an abyss of glamour encroached upon by a flood of innocence."[11] In *The Deep*, Pollock abandoned the vehemence of his previous work, fixing the movement of his "drip" paintings to achieve a more introspective expression that marked a new stage in his development.

As Dominique de Menil avowed in her letter to Hulten, three other donations of American art were to follow. Given between 1975 and 1976, works by Claes Oldenburg, Larry Rivers, and Warhol — none of these men had been represented heretofore in the collection — also hung in the

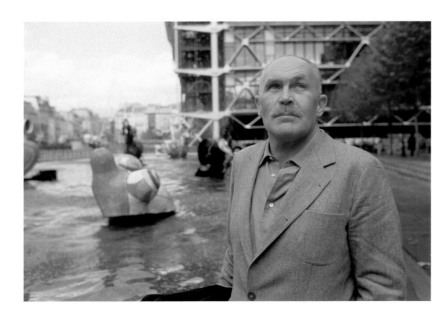

FIGURE 28. Pontus Hulten, November 1984. Courtesy © Sergio Gaudenti / Kipa / Corbis.

galleries at the inauguration. Each of these artists had come into his own in the 1960s with the advent of Pop Art, and the three examples selected for the MNAM all embody the contributions of that movement. Hulten and de Menil were equally familiar with the artists: Hulten had exhibited their work in Stockholm several times, and de Menil had purchased examples by them for her collection early on. The selection of these artists fulfilled the aims of the museum, but the choice of works to represent them was very carefully considered. Oldenburg's *Ghost Soft Drum Set*, 1972 (plate 38, p. 109), is a fairly typical example of the artist's practice of translating quotidian objects into soft, flabby forms that seem close to collapse. The de Menils acquired *Giant Soft Fan, Ghost Version*, which is in the same style, for the Museum of Fine Arts, Houston (plate 4, p. 41), and in all likelihood, the purchase for the MNAM, which was handled by the dealer Leo Castelli, pleased Dominique de Menil. Unlike the Oldenburg work, those by Rivers and Warhol had been in the de Menils' collection and demonstrate clearly what we might call the "Menil touch." The former expresses Dominique de Menil's passionate attitude toward the scourge that she and Jean combatted ardently in their own community: racism. The latter addresses the highly contentious subject of capital punishment.

One can just imagine Dominique de Menil's jubilation at having enabled Rivers's *I Like Olympia in Black Face*, 1970 (plate 40, p. 111), to enter a French national collection. Here, the artist "corrected" Manet's *Olympia*, a treasure of the French cultural heritage, in which a black female servant offers a bouquet to her white mistress, by reversing the women's races: a white maid now serves a black Olympia. Even the cat, which in Manet's painting is black, has become white. The force of this volumetric image, with its strong graphism — typical of Rivers — derives from both its theme and its racial inversion. The painting dates from the time of the black power movement in the United States, when racial strife was particularly intense. The de Menils also owned Rivers's painting *African Continent and Africans*, 1970 (see figure 30). Thus, from Couwenberg's seventeenth-century representation of a black woman and two white men to Rivers's composition, the de Menils' belief that art can contribute to changing attitudes was consistent and clear.

Warhol's *Electric Chair*, 1967 (plate 42, p. 113), is one of a sequence of works by the artist dealing with mortality.[12] This cold and tragic representation of mechanized death is one of the most effective in Warhol's Disaster series, which he began in 1963. The painting had been included in Warhol's first museum retrospective — which Hulten had organized a few years before in Stockholm — and was part of its long European tour. Hulten was particularly attached to a dozen paintings, including this one that Warhol had created especially for the show. Donated by the artist to the Menil Foundation

FIGURE 29. Renzo Piano (b. 1937) and Richard Rogers (b. 1933). Centre Georges Pompidou, Paris, completed 1976. Courtesy Vanni / Art Resource, NY.

shortly after the exhibition closed, *Electric Chair* is a strong political statement. As in the case of the Pollock, the Warhol selected for the MNAM addresses a more unexpected and tougher subject than one of the artist's images of soup cans or flowers, which were very much in vogue at the time.

The quartet of American works that was thus in place for the opening of the Centre Pompidou represented neither the particular tastes of a collector who gives whatever work he or she selects nor those of a museum director who has "gone shopping" in a private collection. Rather, these donations resulted from a true collaboration between two strong individuals working together in perfect harmony. In addition, Dominique de Menil lent two paintings by Rothko for the inauguration (and several months thereafter); they complemented the single Rothko in the museum's collection that had been bought a few years before. And there were gifts from two of the de Menils' children: Francois presented a large work by Joseph Cornell, *Owl Box*, 1945–46; and Georges and his wife, Lois, gave a major painting by Helen Frankenthaler, *Spring Bank*, 1974. The Cornell relates to the Surrealist work that dominated the de Menils' collection, where this artist was well represented, while the Frankenthaler is a fine example of the second phase of Abstract Expressionism, a movement that was at the heart of Georges and Lois de Menil's collection.

Dominique de Menil's efforts did not end there. Her letter of April 12, 1974, declares her intention to call upon other sources of support, in particular "the French affairs [corporations] that are working in America." The American practice of creating philanthropic foundations to support various causes, including the arts, was relatively unknown in France at the time. In 1977, at Hulten's suggestion, the Georges Pompidou Art and Culture Foundation was created; its honorary president was Mme Georges Pompidou, but its actual leader was none other than Dominique de Menil. The foundation's overarching aim was to facilitate cultural exchange between the United States and France in order to make American artists better known in France and vice versa. It supported exhibitions, such as a 1982 Yves Klein show that opened in Houston and then went to Paris in the following year, in which Dominique de Menil played a crucial role. But the foundation was devoted mainly to facilitating acquisitions for the MNAM. Despite her many activities in Houston, de Menil was the main force behind the foundation. Focusing on wealthy collectors, she organized trips to Europe and visits to private collections. In part through her efforts, Castelli, Arnold Glimcher, Samuel Mercer, Annalee Newman, and Hélène and Michel David-Weill (a member of the foundation's board) all donated important works to the Centre Pompidou.[13]

FIGURE 30. Dominique de Menil discussing Larry Rivers's *African Continent and Africans*, 1970, at the exhibition "La rime et la raison: Les collections Ménil (Houston–New York)" at the Galeries Nationales du Grand Palais, Paris, April 17–July 30, 1984.

In 1981 Pontus Hulten left the MNAM after a long and seminal reign as director. His position was assumed by Dominique Bozo. A former curator at the MNAM, he returned to the museum after preparing for the opening of the Musée Picasso, Paris. Bozo forged a very warm relationship with Dominique de Menil. In honor of Hulten on the occasion of his departure, de Menil donated *Thira*, 1979–80, an important work by Brice Marden.[14] *Thira* had caught Bozo's attention at a Marden exhibit he attended in New York. He wrote to de Menil, "You know how enthusiastic I am about this piece, because when I saw it at the Pace Gallery, I tried to acquire it for the museum."[15] The work's monochrome panels create a kind of triptych and also suggest portals (*thira* means "door" in Greek). Its structured and sensitive abstraction appealed to the sensibilities of both Dominiques. Dominique de Menil must have responded to its synchronicity with the Rothkos in the Houston chapel and with the works by Cy Twombly she owned. Director and patron must also have been drawn to Marden's subtle references to ancient or faraway civilizations.

Bozo began making plans for an exhibition of de Menil family gifts (figures 31–34).[16] He brought together the seven works donated since 1975 (as well as the Fernandez painting Jean and Dominique de Menil had donated earlier). The press release stated that these pieces "not only express the tastes and exigencies of each member of this American and French family, but also and in conjunction, have opened the national collections to new horizons, other forms of thought and expression."[17]

This show opened the day after "La rime et la raison: Les collections Ménil (Houston–New York)," an extensive exhibition at the Galeries Nationales du Grand Palais, Paris, of over six hundred works from the de Menils' and their children's collections (figures 30, 35).[18] Dedicated to the memory of Jean de Menil, "La rime et la raison" began with a space conceived by the French artist Jean-Pierre Raynaud (who would later show his work in Houston), containing four works chosen to represent Paleolithic, African, Byzantine, and contemporary art (a sculpture by Yves Klein) (figure 35). With this startling, remarkably succinct introduction, the exhibition continued in the same unorthodox fashion, mixing masterpieces from diverse civilizations and time periods. Absolutely exceptional were the selections of Native American, Polynesian, and West African art, not to mention the collection's extraordinary representation of Surrealist and postwar American art. While struck by the unique non-historical display, the public was perhaps most impressed by the de Menils' exceptional eye for quality. One of the curators involved in the show, Jean-Yves Mock, had collaborated closely with Hulten at the MNAM and continued under Bozo to

FIGURES 31–34. Installation views of "Dons de la famille de Ménil au Musée National d'Art Moderne," Centre Pompidou, Paris, April 18–June 11, 1984.

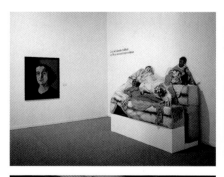
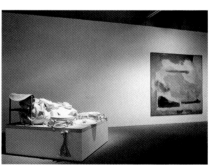
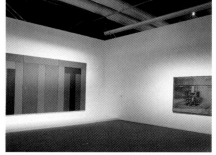
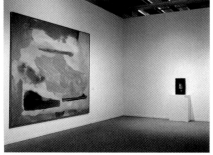

work directly with Dominique de Menil in her Centre Pompidou-related activities, including the Art and Culture Foundation, for which he served as liaison.

The year 1984 also marked the Menil Foundation's last donation to the Pompidou, *Blue II*, 1961 (figure 36), a large painting by Joan Miró that once formed part of a triptych. One of Bozo's dreams was to reunite the three canvases, which Miró had executed in his studio in Mallorca. After their original presentation together at the Galerie Maeght in Paris in the summer of 1961, they were not seen together again until the Miró retrospective at the Grand Palais in 1974. Miró said that "these paintings are the realization of everything I had tried to do."[19] They marked his return, on a monumental scale, to his 1925 "dream paintings," with their colored fields punctuated with symbols. One can find the same blue in these earlier paintings; in one of the most famous, he had connected a spot of this hue to the sentence, "Ceci est la couleur de mes rêves" (This is the color of my dreams).[20] In the 1961 canvases, the artist combined huge scale — as large as works being made at that time by American Abstract Expressionists — with a great economy of means: a simple line and a few dots: "With these very economical lines that I inscribed . . . ," Miró stated, "I sought to render this gesture with such individuality that it became almost anonymous and thus attained the universality of the action."[21]

The Centre Pompidou's acquisition of *Blue II* was the first step toward having all three *Blues*. This project involved the canny assistance of the dealer Pierre Matisse and the support, once again, of Dominique de Menil. That she made this gift during the exhibition at the Grand Palais was obviously not coincidental. It was her way of expressing gratitude to France for having thus honored her collection. The French minister of culture, Jack Lang, thanked her: "With this gesture, you are also making a gesture to France, this country that was so important to Miró and other artists as a welcoming home, a place to work and experiment. I cannot but be moved by this testimony, at a time when the government is doing its utmost to restore the full meaning to the word Culture."[22] *Blues I–III* were exhibited at the Centre Pompidou beginning in late 1984, one year after Miró's death. The museum acquired *Blue III* in 1988 and *Blue I* in 1993. Dominique Bozo died prematurely, shortly after the museum realized the dream he had so ardently pursued.

After 1984 Dominique de Menil focused all her efforts on the creation in Houston of The Menil Collection. When she referred to her work on behalf of the Centre Pompidou, she was straightforward in setting out her priorities: "I wish I could do more for the Georges Pompidou Museum, but now I must think of the new museum in Houston. Indeed, there are works I would like to add, but we will wait."[23]

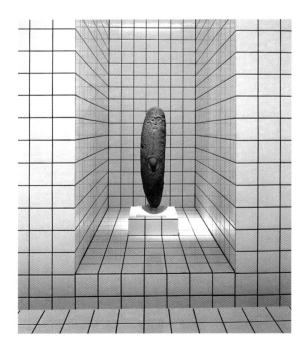

FIGURE 35. Jean-Pierre Raynaud, *L'espace zéro*, installation niche with *Anthropomorphic Monolith (Akwanshi)* (plate 21, p. 61) in "La rime et la raison: Les collections Ménil (Houston–New York)" at the Galeries Nationales du Grand Palais, Paris, April 17–July 30, 1984.

The Georges Pompidou Foundation continued its activities, helping the museum to obtain several important works.[24] By sponsoring such shows as "Les courtiers du désir" ("A Brokerage of Desire"), which in 1987 brought work by Jeff Koons and other artists to Paris for the first time, the foundation continued to demonstrate its commitment to bringing new American art before an international audience.

This essay would not be complete without acknowledging the generous gifts of other members of Dominique de Menil's family. As we have seen, her sons, Francois and Georges, also donated works to the MNAM. Like all of their mother's gifts, theirs were made in memory of Jean de Menil. We must also mention the remarkable efforts of Dominique de Menil's sister Sylvie Boissonnas, who became president of the Friends of the MNAM when the Centre Pompidou opened and who, through the American-based Scaler Foundation, supported the museum's collection over many years. The number of masterpieces acquired with the help of her foundation is impressive, ranging from works by Braque and Piet Mondrian to Matisse, and from Kasimir Malevich to Alberto Giacometti, to name just a few.[25] Another sister, Anne Gruner-Schlumberger, dedicated herself to the Fondation des Treilles, in the province of Var, which donated a work by Ernst to France. Jacques Boissonnas, son of Sylvie and her husband, Eric, continued this extraordinary family tradition through his own organization, the Clarence-Westbury Foundation, which helped the MNAM acquire examples by Mike Kelley, Oldenburg, Tony Oursler, Robert Smithson, James Turrell, and, recently, Marden. In addition, Boissonnas's interest in design has made possible the acquisition of decorative-art objects for the MNAM. A cousin of Dominique and Sylvie's, Pierre Schlumberger, and his wife, Sao, became important patrons during the early years of the Centre Pompidou, having donated *Oracle*, 1976, an exceptional installation by Robert Rauschenberg that Hulten particularly valued, and a painting by Ellsworth Kelly. Recently, Dominque de Menil's nephew Jérôme Seydoux and his wife, Sophie, presented the MNAM with *The Orchestra*, 1953, a major work by the painter Nicolas de Staël. Without the enlightened patronage of the de Menil and Schlumberger families, the Centre Pompidou would certainly not have a collection of the amplitude it currently has. Inspirational patrons, Dominique and Jean de Menil must be credited for the significant part they played in so many generous and essential gifts.

FIGURE 36. Joan Miró (1893–1983). *Blue II*, 1961. Oil on canvas. 106¼ x 139¾ in. (270 x 355 cm). Musée National d'Art Moderne, Centre Georges Pompidou, Paris.

This essay was translated from the French by Marina Harss. Minor spelling and style corrections have been made to direct quotations for purposes of clarity.

1. This essay refers to John de Menil as Jean, his French name; the remaining essays in this volume refer to him as John, which was the name he used in the United States and which he officially adopted in 1962.

2. Jean de Menil to Pierre Quoniam, general inspector of provincial museums, Palais du Louvre, Paris, June 26, 1970, Object Files, The Menil Collection, Houston (hereinafter Menil Object Files). As part of their involvement in the civil rights movement, the de Menils implemented an ambitious project that involved amassing depictions of blacks throughout the history of Western art. The project, begun in 1960, resulted in a vast archive of images that formed the basis of a multivolume, scholarly survey entitled *The Image of the Black in Western Art*. The archive was relocated from the Menil Foundation to Harvard University, Cambridge, Mass., in 1994.

3. Dominique de Menil to Pierre Devambez, Apr. 16, 1971, Menil Object Files.

4. Werner Hofmann, et al., *Max Ernst: Inside the Sight*, exh. cat. (Houston: Institute for the Arts, Rice University, 1973), p. 5.

5. "When we discussed putting together the wonderful project of a Fernandez retrospective at the CNAC," wrote Blaise Gautier, "[Jean] de Menil spoke to me of the Menil Foundation's great interest in finding an echo outside of Paris, at another institution, for the exhibit. The idea was to show these very unique works and this solitary artist to a larger and more diverse audience." Gautier to Dominique de Menil, May 13, 1974, Menil Archives, The Menil Collection, Houston (hereinafter Menil Archives). Three of Fernandez's works were included in "La rime et la raison: Les collections Ménil (Houston–New York)," a monumental exhibition in Paris of the de Menil family's collections (see note 18 below), which indicates Dominique de Menil's attachment to this artist's oeuvre.

6. Interview with Dominique de Menil, in *The First Show: Painting and Sculpture from Eight Collections 1940–1980*, exh. cat. (Los Angeles: Museum of Contemporary Art, 1983), p. 42.

7. Dominique de Menil to Pontus Hulten, Mar. 8, 1974, Menil Archives.

8. Dominique de Menil to Hulten, Feb. 23, 1974, Archives, Centre Pompidou, Paris (hereinafter Pompidou Archives).

9. Dominique de Menil to Hulten, Apr. 12, 1974. The translation cited here is dated May 16, 1975. Both documents are in the Menil Object Files.

10. *The Natural Paradise: Painting in America 1800–1950*, exh. cat. (New York: Museum of Modern Art, 1976). Shown first at the Sidney Janis Gallery, New York, while Pollock was still alive, *The Deep* was included in an exhibition of the artist's work that traveled in Europe in 1958–59. More to the point, Hulten had displayed it in Stockholm at the Moderna Museet in 1963 and doubtless remembered it from that time.

11. Frank O'Hara, *Art Chronicles, 1954–1966* (New York: George Braziller, 1975), pp. 37–38.

12. *Electric Chair* (plate 42, p. 113) is one of two paintings of the subject that Warhol gave to the Menil Foundation in 1969; the other is *Big Electric Chair*, 1967 (plate 44, p. 115). The year before, the Menil Foundation purchased *Big Electric Chair*, 1967 (plate 43, p. 114).

13. For example, the dealer Leo Castelli donated an important work by Dan Flavin, *Untitled (To Donna) 5a*, 1971, to the MNAM through the foundation.

14. *Thira* was initially given in trust, and then outright, by the Georges Pompidou Art and Culture Foundation.

15. Dominique Bozo to Dominique de Menil, July 1, 1981, Pompidou Archives.

16. "Dons de la famille de Ménil au Musée National d'Art Moderne" ran from April 18–June 11, 1984.

17. Press release for "Dons de la famille" (note 16), Pompidou Archives.

18. "La rime et la raison: Les collections Ménil (Houston–New York)" ran from April 17–July 30, 1984. The exhibition comprised works from the collections of Christophe de Menil, Adelaide de Menil and Edmund Carpenter, Georges and Lois de Menil, Francois de Menil, Philippa and Heiner Friedrich and Francesco Pellizzi.

19. Joan Miró, as quoted in Rosamond Bernier, comp., "Propos de Joan Miró," *L'Oeil* 79–80 (July–Aug. 1961), p. 18.

20. The painting, *Photo: This Is the Color of My Dreams*, 1925, is in the Metropolitan Museum of Art, New York.

21. Miró (note 19).

22. Jack Lang to Dominique de Menil, Dec. 10, 1984, Menil Archives.

23. Dominique de Menil (note 6), p. 47.

24. For example, Castelli gave Flavin's *"monument" for V. Tatlin*, 1975, in 1992; Samuel Mercer presented Eva Aeppli's *Group of 13 (Homage to Amnesty International)*, 1968, in the same year. The model for *Seven Poles*, 1970 — Eva Hesse's last work — entered the collection, thanks to the GP Foundation, in 1993.

25. See *La culture pour vivre (Donations des fondations Scaler et Clarence-Westbury)*, exh. cat. (Paris: Centre Pompidou, 2002).

PLATE 35. Jackson Pollock (1912–1956). *The Deep*, 1953. Oil and enamel on canvas. 86¾ x 59 in. (220.3 x 149.9 cm).

PLATE 36. Jackson Pollock (1912–1956). *Untitled*, 1951.
Ink and watercolor on Japanese paper. 25 x 39¼ in. (63.5 x 99.5 cm).

THE MENIL COLLECTION, HOUSTON

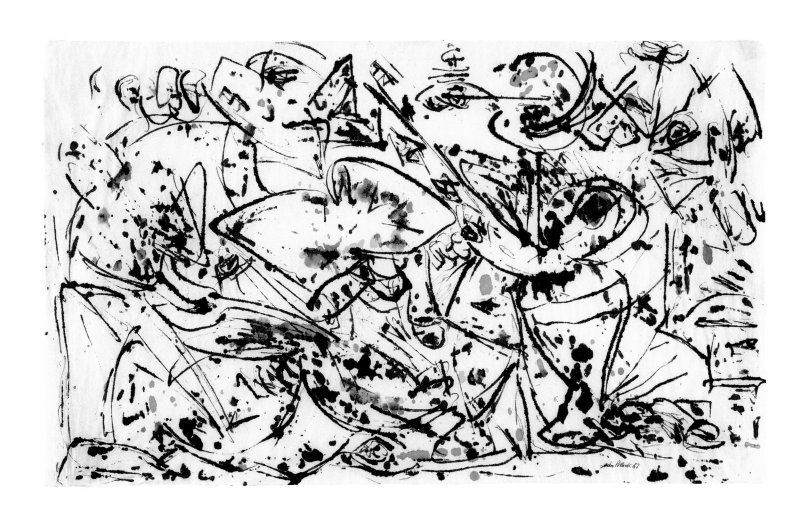

PLATE 37. Jackson Pollock (1912–1956). *Untitled*, 1951.
Ink on mulberry paper. 25¾ x 39 in. (irreg.) (65.4 x 99 cm [irreg.]).

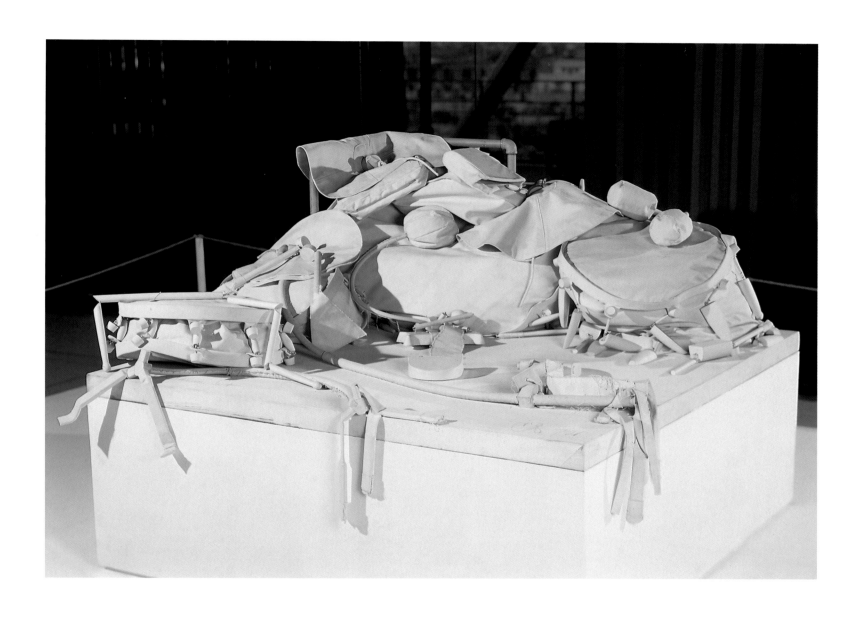

PLATE 38. Claes Oldenburg (b. 1929). *Ghost Soft Drum Set*, 1972.
Sewn and painted canvas filled with polystyrene on a base. 31½ x 72 x 72 in. (80 x 182.9 x 182.9 cm).
CENTRE POMPIDOU, PARIS, MUSÉE NATIONAL D'ART MODERNE/CENTRE DE CRÉATION INDUSTRIELLE;
GIFT OF THE MENIL FOUNDATION IN 1975 (IN MEMORY OF JEAN DE MENIL)

PLATE 39. Larry Rivers (1923–2002). *George Washington*, 1953.
Collage on paper. 13⅞ x 15⅜ in. (35.2 x 39.1 cm).

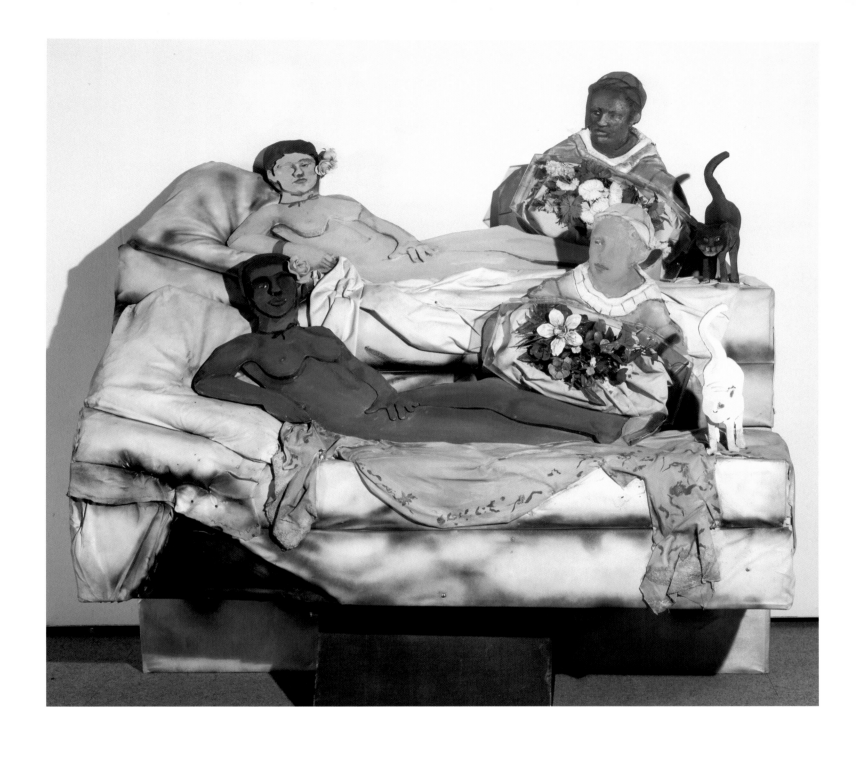

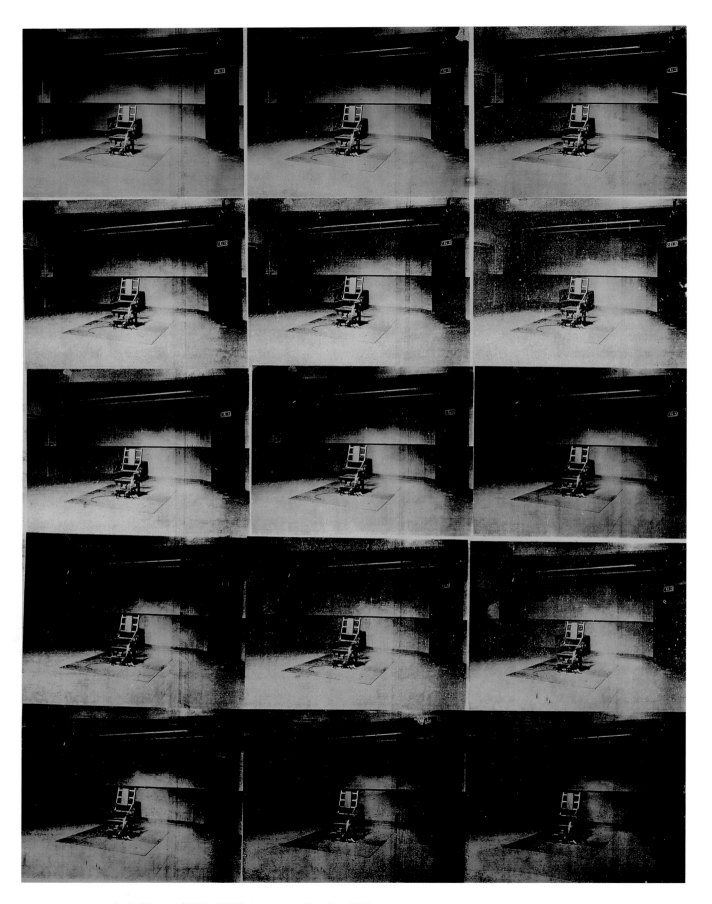

PLATE 41. Andy Warhol (1928–1987). *Lavender Disaster*, 1963.
Silkscreen ink and acrylic on canvas. 106 x 81⅞ in. (269.2 x 208 cm).

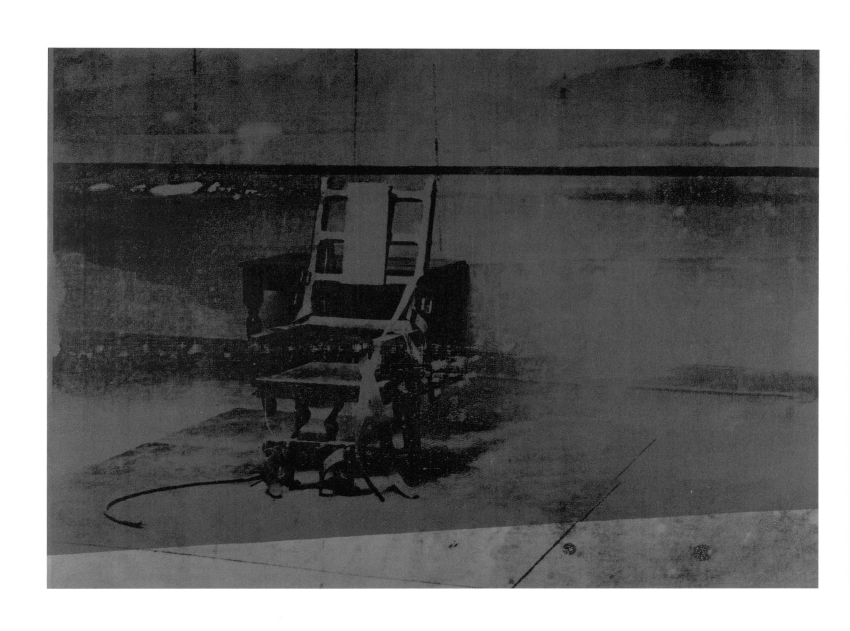

PLATE 42. Andy Warhol (1928–1987). *Electric Chair*, 1967.
Silkscreen enamel and acrylic on canvas. 54 x 73 in. (137.2 x 185.3 cm).

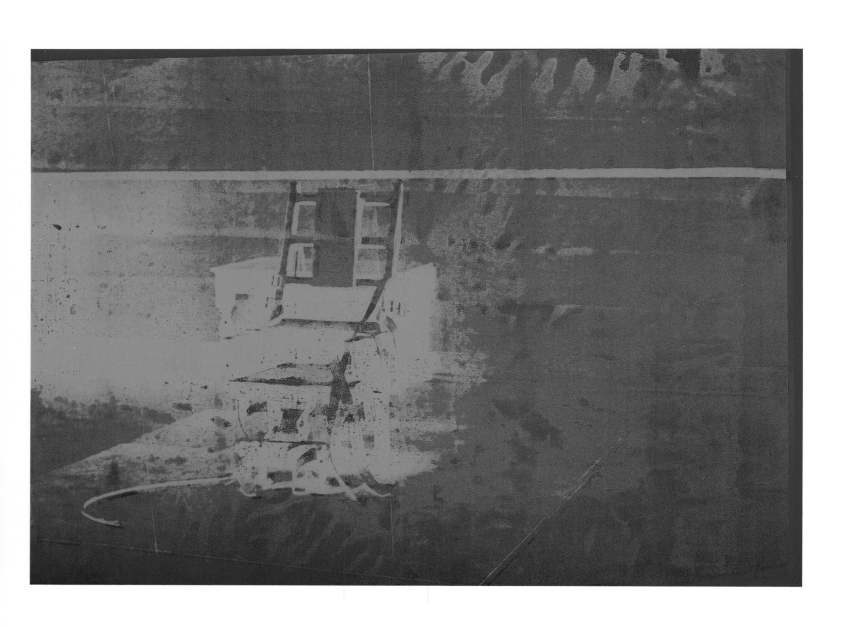

PLATE 43. Andy Warhol (1928–1987). *Big Electric Chair*, 1967.
Silkscreen enamel and acrylic on canvas. 54 x 73⅛ in. (137.2 x 185.7 cm).

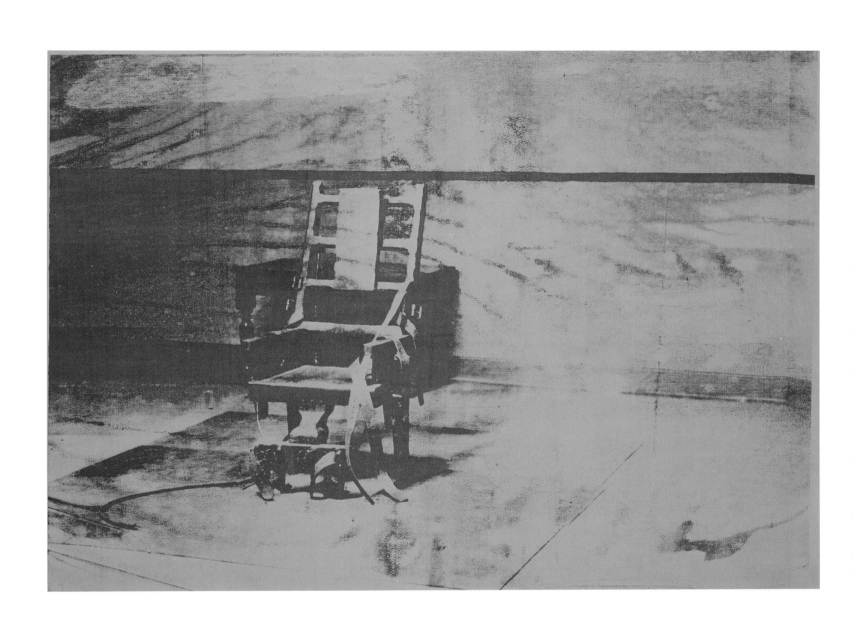

PLATE 44. Andy Warhol (1928–1987). *Big Electric Chair*, 1967.
Silkscreen enamel and acrylic on canvas. 54¼ x 74 in. (137.8 x 188 cm).

LIST OF PLATES

Non-Western art is listed by region. All other works are listed
alphabetically by artist and then chronologically by piece.

Ceremonial Trough with Horse's Head and Tail
Dogon, 18th or early 19th century
Wood
18 x 76¾ x 19½ in. (45.7 x 195 x 49.5 cm)
THE MUSEUM OF FINE ARTS, HOUSTON;
GIFT OF D. AND J. DE MENIL (64.11)
PLATE 19, P. 58

Molo Mask
Burkina Faso; Bobo, 20th century
Polychromed wood
65½ x 14 x 13½ in. (166.4 x 35.6 x 34.3 cm)
THE MUSEUM OF FINE ARTS, HOUSTON;
GIFT OF D. AND J. DE MENIL IN MEMORY OF
DR. JERMAYNE MACAGY (64.13)
PLATE 18, P. 57

Vessel (Kuduo)
Ghana; Asante, n.d.
Copper alloy cast by lost-wax process
10⅝ x 9½ x 9¼ in. (26.9 x 24 x 23.5 cm)
MUSÉE DU QUAI BRANLY, PARIS; DE MENIL GIFT, 1965
(INV: 71.1965.17.1, FROM THE MUSÉE DE L'HOMME, PARIS)
PLATE 3, P. 15

Bedu Mask
**Côte d'Ivoire and Ghana; Nafana, Kulango,
or Degha, 1940–50**
Wood with paint and metal cut from kerosene tank
62 x 19¾ x 3 in. (157.5 x 50.2 x 7.6 cm)
THE MENIL COLLECTION, HOUSTON
PLATE 15, P. 54

Bedu Mask
**Côte d'Ivoire and Ghana; Nafana, Kulango,
or Degha, 20th century**
Polychromed wood
108 x 50 x 4 in. (274.3 x 127 x 10.2 cm)
THE MUSEUM OF FINE ARTS, HOUSTON;
GIFT OF D. AND J. DE MENIL (62.2)
PLATE 16, P. 55

Anthropomorphic Monolith (Akwanshi)
Cross River region, Nigeria; ca. 16th–19th century
Stone
41 x 15 x 8 in. (104.1 x 38.1 x 20.3 cm)
THE MENIL COLLECTION, HOUSTON
PLATE 21, P. 61

Standard Bearer
Aztec, 1425–1521
Volcanic stone
47½ x 16 x 13¼ in. (120.7 x 40.6 x 33.7 cm)
THE MUSEUM OF FINE ARTS, HOUSTON;
GIFT OF D. AND J. DE MENIL (66.8)
PLATE 20, P. 59

Ceremonial Feast Bowl
Matankor, ca. 19th century
Wood and plant fiber
25¾ x 52⅞ in. (65.4 x 134.3 cm)
THE MUSEUM OF FINE ARTS, HOUSTON;
GIFT OF D. AND J. DE MENIL (62.4)
PLATE 17, P. 56

Lee Bontecou (b. 1931)
Untitled, 1962
Welded steel, epoxy, canvas, fabric, saw blade, and wire
68 x 72 x 30 in. (172.7 x 182.9 x 76.2 cm)
THE MUSEUM OF FINE ARTS, HOUSTON;
GIFT OF D. AND J. DE MENIL (62.45)
PLATE 11, P. 49

Lee Bontecou (b. 1931)
Untitled, 1963
Graphite on muslin
36⅛ x 36¼ x 1 in. (91.6 x 92 x 2.5 cm)
THE MENIL COLLECTION, HOUSTON,
GIFT OF ADELAIDE DE MENIL CARPENTER
PLATE 10, P. 48

Christo (b. 1935)
Empaquetage of a Public Building, Project for the Galleria Nazionale d'Arte Moderna, Rome, 1967
Photomontage and pencil on paper
24 x 34 in. (61 x 86.4 cm)
THE MENIL COLLECTION, HOUSTON
PLATE 33, P. 88

Christo (b. 1935)
Wrapped Museum, Project for the Galleria Nazionale d'Arte Moderna, Rome, 1967–68
Fabric and twine on wood, mounted on
painted wood base
10 x 48 x 24 in. (25.4 x 121.9 x 61 cm)
THE MENIL COLLECTION, HOUSTON
PLATE 34, P. 89

Christo (b. 1935)
The Museum of Modern Art Packaged, 1968
Scale model: painted wood, fabric, twine,
and polyethylene
16 x 48⅛ x 24⅛ in. (40.6 x 122.2 x 61.3 cm)
THE MUSEUM OF MODERN ART, NEW YORK,
GIFT OF D. AND J. DE MENIL, 1968
PLATE 31, P. 86

Christo (b. 1935)
The Museum of Modern Art Packaged Project, 1968
Cut-and-pasted gelatin silver prints (by Ferdinand Boesch) with oil on board, pencil, colored pencil, cut-and-pasted tracing paper, and pressure-sensitive tape on board
21¾ x 15½ in. (55.2 x 39.4 cm)
THE MUSEUM OF MODERN ART, NEW YORK,
GIFT OF D. AND J. DE MENIL, 1968
PLATE 32, P. 87

Max Ernst (1891–1976)
Asperges de la lune (*Lunar Asparagus*), 1935,
cast 1972
Bronze, edition 6/6
64½ x 13 x 8½ in. (163.8 x 33 x 21.6 cm)
THE MENIL COLLECTION, HOUSTON
PLATE 1, P. 12

Max Ernst (1891–1976)
The King Playing with the Queen, 1944, cast 1954
Bronze, edition 2/9
37¾ x 33 x 21¼ in. (95.9 x 83.8 x 54 cm)
THE MENIL COLLECTION, HOUSTON
PLATE 2, P. 13

René Magritte (1898–1967)
L'empire des lumières II (*The Empire of Light II*), 1950
Oil on canvas
31 x 39 in. (78.7 x 99.1 cm)
THE MUSEUM OF MODERN ART, NEW YORK,
GIFT OF D. AND J. DE MENIL, 1951
PLATE 22, P. 76

René Magritte (1898–1967)
L'empire des lumières (*The Dominion of Light*), 1954
Oil on canvas
63¾ x 51⅛ in. (161.9 x 129.9 cm)
THE MENIL COLLECTION, HOUSTON
PLATE 23, P. 77

René Magritte (1898–1967)
Le monde invisible (*The Invisible World*), 1954
Oil on canvas
77 x 51⅝ in. (195.6 x 131.1 cm)
THE MENIL COLLECTION, HOUSTON
PLATE 24, P. 78

René Magritte (1898–1967)
Souvenir de voyage (*Memory of a Voyage*), 1955
Oil on canvas
63⅞ x 51¼ in. (162.2 x 130.2 cm)
THE MUSEUM OF MODERN ART, NEW YORK,
GIFT OF D. AND J. DE MENIL, 1959
PLATE 27, P. 81

René Magritte (1898–1967)
La clef de verre (*The Glass Key*), 1959
Oil on canvas
51⅛ x 63¾ in. (129.9 x 161.9 cm)
THE MENIL COLLECTION, HOUSTON
PLATE 25, P. 79

Man Ray (1890–1976)
Portrait imaginaire de D. A. F. de Sade (*Imaginary Portrait of D. A. F. de Sade*), 1938
Oil on canvas with painted wood panel
24¼ x 18⅜ in. (61.7 x 46.6 cm)
THE MENIL COLLECTION, HOUSTON
PLATE 26, P. 80

Claes Oldenburg (b. 1929)
Giant Soft Fan, Ghost Version, 1967
Canvas, wood, and foam rubber
96 x 54¼ x 73 in. (243.8 x 137.7 x 185.4 cm)
THE MUSEUM OF FINE ARTS, HOUSTON;
GIFT OF D. AND J. DE MENIL (67.18.A, B)
PLATE 4, P. 41

Claes Oldenburg (b. 1929)
Ghost Soft Drum Set, 1972
Sewn and painted canvas filled with polystyrene on a base
31½ x 72 x 72 in. (80 x 182.9 x 182.9 cm)
CENTRE POMPIDOU, PARIS, MUSÉE NATIONAL D'ART
MODERNE/CENTRE DE CRÉATION INDUSTRIELLE;
GIFT OF THE MENIL FOUNDATION IN 1975 (IN MEMORY
OF JEAN DE MENIL)
PLATE 38, P. 109

Jackson Pollock (1912–1956)
The Magic Mirror, 1941
Oil, granular filler, and glass fragment on canvas
46 x 32 in. (116.8 x 81.3 cm)
THE MENIL COLLECTION, HOUSTON
PLATE 13, P. 52

Jackson Pollock (1912–1956)
Number 6, 1949
Duco and aluminum paint on canvas
44³⁄₁₆ x 54 in. (112.2 x 137.2 cm)
THE MUSEUM OF FINE ARTS, HOUSTON;
GIFT OF D. AND J. DE MENIL (64.36)
PLATE 12, P. 51

Jackson Pollock (1912–1956)
Untitled, 1951
Ink on mulberry paper
25¾ x 39 in. (irreg.) (65.4 x 99 cm [irreg.])
THE MENIL COLLECTION, HOUSTON
PLATE 37, P. 107

Jackson Pollock (1912–1956)
Untitled, 1951
Ink and watercolor on Japanese paper
25 x 39¼ in. (63.5 x 99.5 cm)
THE MENIL COLLECTION, HOUSTON
PLATE 36, P. 106

Jackson Pollock (1912–1956)
The Deep, 1953
Oil and enamel on canvas
86¾ x 59 in. (220.3 x 149.9 cm)
CENTRE POMPIDOU, PARIS, MUSÉE NATIONAL D'ART
MODERNE/CENTRE DE CRÉATION INDUSTRIELLE; GIFT OF
THE MENIL FOUNDATION IN 1976 (IN MEMORY OF JEAN DE
MENIL BY HIS CHILDREN AND BY THE MENIL FOUNDATION)
PLATE 35, P. 105

Larry Rivers (1923–2002)
George Washington, 1953
Collage on paper
13⅞ x 15⅜ in. (35.2 x 39.1 cm)
THE MENIL COLLECTION, HOUSTON
PLATE 39, P. 110

Larry Rivers (1923–2002)
I Like Olympia in Blackface, 1970
Oil on wood, plastic, and Plexiglas
71⅝ x 76½ x 39½ in. (182 x 194 x 100 cm)
CENTRE POMPIDOU, PARIS, MUSÉE NATIONAL D'ART
MODERNE/CENTRE DE CRÉATION INDUSTRIELLE;
GIFT OF THE MENIL FOUNDATION IN 1976 (IN MEMORY
OF JEAN DE MENIL)
PLATE 40, P. 111

Mark Rothko (1903–1970)
Astral Image, 1946
Oil on canvas
44⅛ x 33⅞ in. (112.1 x 86 cm)
THE MENIL COLLECTION, HOUSTON,
BEQUEST OF JERMAYNE MACAGY
PLATE 14, P. 53

Jean Tinguely (1925–1991)
Meta-Mécanique Relief, 1954
Steel-tube frame, steel wire, painted cardboard,
and electric motor
33½ x 55⅛ x 14⅛ in. (85.1 x 140 x 35.9 cm)
THE MUSEUM OF FINE ARTS, HOUSTON;
GIFT OF D. AND J. DE MENIL (65.13)
PLATE 5, P. 43

Jean Tinguely (1925–1991)
Bascule, 1960
Steel rods, steel wire, aluminum pulley, brass bell, round rubber belt, and electric motor
32 x 18 x 14 in. (81.3 x 45.7 x 35.6 cm)
THE MUSEUM OF FINE ARTS, HOUSTON;
GIFT OF D. AND J. DE MENIL (65.17)
PLATE 7, P. 45

Jean Tinguely (1925–1991)
Sketch for Eureka, 1963
Pencil and ink on paper
9¾ x 13¾ in. (24.8 x 34.9 cm)
THE MENIL COLLECTION, HOUSTON
PLATE 8, P. 46

Jean Tinguely (1925–1991)
M. K. III, 1964
Steel, steel-pipe section, iron wheels, rubber V-belt, flat belt, and electric motor
36¼ x 82⅛ x 38½ in. (92.1 x 209.6 x 97.8 cm)
THE MUSEUM OF FINE ARTS, HOUSTON;
GIFT OF D. AND J. DE MENIL (65.20)
PLATE 9, P. 47

Jean Tinguely (1925–1991)
Drawing for Bascule #5, 1965
Pentel pen and ink on paper
12 x 17⅞ in. (30.5 x 45.4 cm)
THE MENIL COLLECTION, HOUSTON
PLATE 6, P. 44

Andy Warhol (1928–1987)
Lavender Disaster, 1963
Silkscreen ink and acrylic on canvas
106 x 81⅞ in. (269.2 x 208 cm)
THE MENIL COLLECTION, HOUSTON
PLATE 41, P. 112

Andy Warhol (1928–1987)
Big Electric Chair, 1967
Silkscreen enamel and acrylic on canvas
54 x 73⅛ in. (137.2 x 185.7 cm)
THE MENIL COLLECTION, HOUSTON
PLATE 43, P. 114

Andy Warhol (1928–1987)
Big Electric Chair, 1967
Silkscreen enamel and acrylic on canvas
54¼ x 74 in. (137.8 x 188 cm)
THE MENIL COLLECTION, HOUSTON, GIFT OF THE ARTIST
PLATE 44, P. 115

Andy Warhol (1928–1987)
Electric Chair, 1967
Silkscreen enamel and acrylic on canvas
54 x 73 in. (137.2 x 185.3 cm)
CENTRE POMPIDOU, PARIS, MUSÉE NATIONAL D'ART
MODERNE/CENTRE DE CRÉATION INDUSTRIELLE;
GIFT OF THE MENIL FOUNDATION IN 1976 (IN MEMORY
OF JEAN DE MENIL)
PLATE 42, P. 113

Wols (Alfred Otto Wolfgang Schulze) (1913–1951)
Painting, 1946–47
Oil on canvas
31⅞ x 32 in. (81 x 81.3 cm)
THE MUSEUM OF MODERN ART, NEW YORK,
GIFT OF D. AND J. DE MENIL FUND, 1956
PLATE 29, P. 84

Wols (Alfred Otto Wolfgang Schulze) (1913–1951)
Untitled (*It's All Over* or *The City*), 1946–47
Oil on canvas
31⅞ x 31⅞ in. (81 x 81 cm)
THE MENIL COLLECTION, HOUSTON
PLATE 30, P. 85

Wols (Alfred Otto Wolfgang Schulze) (1913–1951)
Manhattan, 1948–49
Oil on canvas
57½ x 38⅜ in. (146.1 x 97.5 cm)
THE MENIL COLLECTION, HOUSTON
PLATE 28, P. 83

Photography Credits

© Eve Arnold / Magnum Photos (figure 8)

Bridgeman-Giraudon / Art Resource, NY, Musée d'Art Moderne de la Ville de Paris, Paris, France (plate 38)

CNAC / MNAM / Dist. Réunion des Musées Nationaux / Art Resource, NY, Musée National d'Art Moderne,
 Centre Georges Pompidou, Paris, France (plates 35, 40, 42)

CNAC / 7.5 pt / Dist. Réunion des Musées Nationaux / Art Resource, NY,
 Musée d'Art Moderne de la Ville de Paris, Paris, France (figure 36)

A. de Menil (figure 12)

Jacques Faujour (plate 35)

© Sergio Gaudenti / Kipa / Corbis (figure 28)

© 2006 Patrick Gries / Valérie Torre / SCALA, Florence, Musée du Quai Branly, Paris (plate 3)

J. Hain, Paris (figure 35)

Béatrice Hatala (figures 31–34)

David Heald © The Solomon R. Guggenheim Foundation, New York (figure 3)

Hester + Hardaway Photographers (plate 21)

Hickey-Robertson, Houston (figures 2, 7, 13, 15, 16, 18, 19, 23)

George Hixson, Houston (plates 1, 5, 7, 15–17, 34)

Jacqueline Hyde (plate 40)

Allen Mewbourn (figure 11)

Philippe Migeat (plate 42)

© André Morain Archive (figures 24, 26)

Robert Motherwell (figure 4)

Digital Image © The Museum of Modern Art / Licensed by SCALA / Art Resource, NY
 (figures 10, 20, 21; plates 22, 27, 29, 31, 32)

Bertrand Prévost (figures 27, 35)

© Marc Riboud / Magnum Photos (figure 30)

John Lee Simons (figures 5, 6)

Vanni / Art Resource, NY (figure 29)

Copyright Credits